Embroidery on Paper

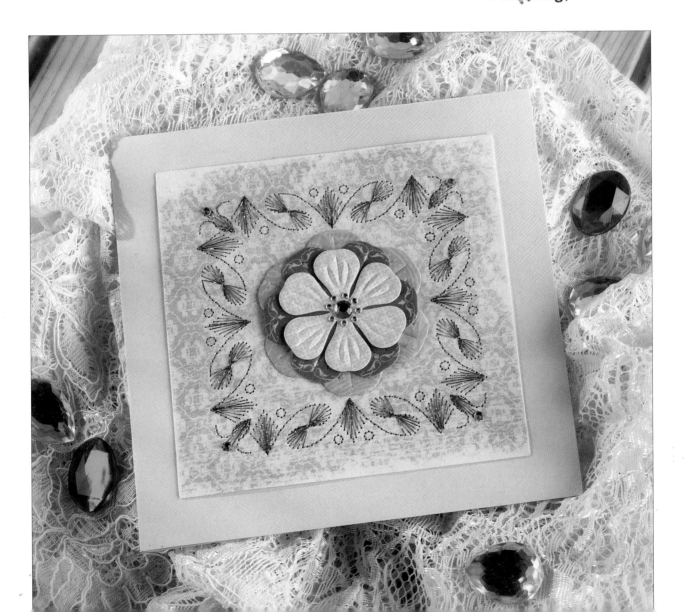

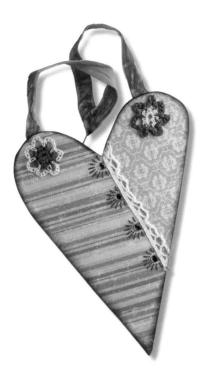

Dedicated to my two lovely children,
Jared and Anna, with all my love.

Embroidery
on Paper

Cynthia Rapson

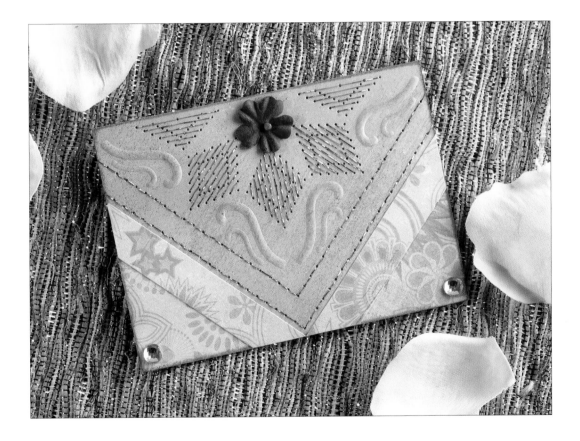

SEARCH PRESS

First published in Great Britain 2008

Search Press Limited
Wellwood, North Farm Road,
Tunbridge Wells, Kent TN2 3DR

Text copyright © Cynthia Rapson 2008

Photographs by Roddy Paine Studios

Photographs and design copyright © Search Press Ltd. 2008

ISBN-13: 978-1-84448-232-0

The Publishers and author can accept no responsibility for any consequences arising from the information, advice or instructions given in this publication.

Readers are permitted to reproduce any of the items in this book for their personal use, or for the purposes of selling for charity, free of charge and without the prior permission of the Publishers. Any use of the items for commercial purposes is not permitted without the prior permission of the Publishers.

Suppliers

If you have difficulty in obtaining any of the materials and equipment mentioned in this book, then please visit the Search Press website for details of suppliers: www.searchpress.com

Materials and equipment are also available from the author's website: www.ginghambuttons.co.uk

Publisher's note

All the step-by-step photographs in this book feature the author, Cynthia Rapson, demonstrating the craft of embroidery on paper. No models have been used.

Acknowledgements

My heartfelt thanks to all the talented people that helped make this book possible:

To everyone at Search Press, especially Roz Dace, Editorial Director, for opening up a fascinating new world of how books are written and published, and for the chance of a lifetime to be part of it.

To my editor, Edd Ralph, for all his talented help, guidance, inspiration and attention to detail. To Ellie Burgess for beautiful and creative styling of the projects. To Roddy Paine and Gavin Sawyer for expert and friendly photography. It takes a lot of patience to photograph needles and paper!

To Kars, for supplying many of the threads, papers and embellishments, and especially the embroidery templates. Also to Bryan and Sue Reeves for their friendly support.

To Ada Daly, Kars UK craft coordinator, for all the wonderful opportunities she has passed my way, and for helping me be in the right place at the right time.

To Superior Threads, for supplying the rainbow and holographic threads.

To Lee, a special thanks and lots of love for being an ordinary hero.

Page 1:
Use holographic thread and craft jewels to make a pretty frame for a three-dimensional paper flower.

Page 2:
Embroidered stitching makes an artist trading card really special.

Opposite:
Even a small amount of stitching makes these little bags stand out from the rest.

Contents

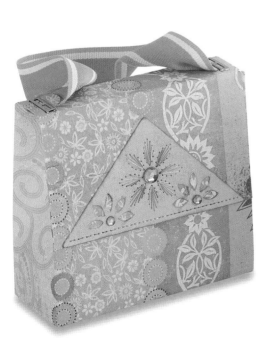

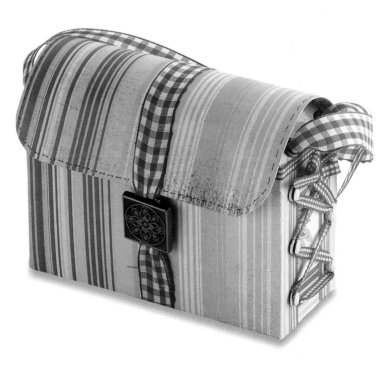

Introduction

I am addicted to beautiful paper, and I love the process of decorating it with embroidered stitching because it adds an heirloom quality to my work. I also find getting lost in the rhythm of the stitches to be peaceful, relaxing and therapeutic.

It seems important in a busy, aggressive and fast-paced life to give ourselves time out to do something creative and quiet.

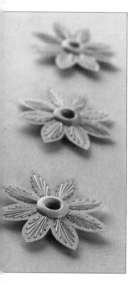

The ideas in this book are designed to be a happy medium between the more time-consuming needlecrafts, and the quickly rushed out projects available where almost everything is already done for you. I really hope you enjoy making the projects in this book as much as I have enjoyed designing them, and I hope you find relaxation and inspiration for making up your own designs.

Cynthia

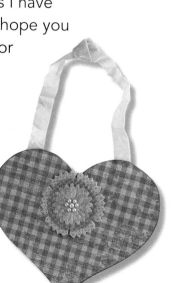

Materials and equipment

To start embroidery on paper, pick up a pretty brass template, some gorgeous thread and a needle, some card or paper, a pricking tool and mat, and a light box if you intend to emboss your work. The process is simple and straightforward, and anyone can do it. The list only becomes endless if you are like me and collect all the brass templates, threads, papers and embellishments!

Brass templates

The brass embroidery templates I have used are just a small selection from a large range – all of them equally beautiful. Choose whichever ones you like the best.

There are lots of design elements on each template, too many for just one project, so choose which bits you want to use.

Where the holes are pricked on the template, you will see etched patterns. These are stitching suggestions which are helpful to use when you start off, but you can make up your own if you wish.

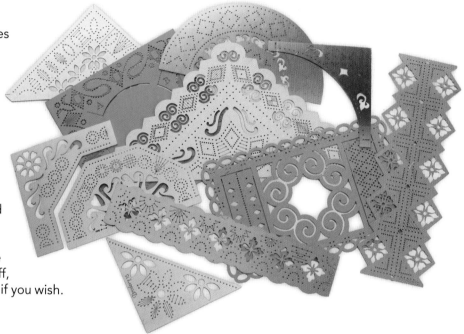

Pricking tools and mats

The pricking tool is used to create the holes for your chosen design, to which you will then add stitching. The pricked holes can also be left as they are, and look quite pretty if you are short on time.

A pricking tool with a handle is most comfortable to use. It does not matter what size the pricking tool is, as the template will determine the size of the hole. The pricking mat needs to be a soft surface so that the tool passes through the template and the card, but does not damage the work surface underneath, or bend the tool. I prefer to use a pricking mat suitable for parchment as these are nice and thick.

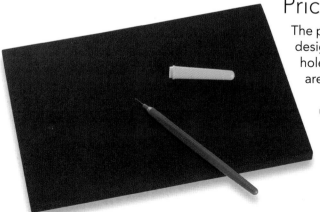

Needles and threads

Any needle can be used, but it is useful to remember that a fine thread should be used with a small-eyed needle, so that the hole does not get too large. If you are using a thicker thread, you will need a larger-eyed needle.

Similarly, any thread can be used, but it is useful to remember that the thread should be matched to the style of the project. For example, a delicate piece of work will look better if you use a fine, shiny thread, and a country-style project will look better if you use a thicker, matt thread. There are so many pretty threads available; experiment with as many as you can afford.

If you have trouble threading a needle, get a sharper-eyed friend to do it, or you could use a needle threader or a magnifying glass to help out.

Papers

Where to begin? Part of the beauty of craftwork is that everybody sees colour differently – so choose papers that you love! A mixture of patterned and plain papers is good, and I tend to choose lots of papers from the same range, rather than one or two from lots of different ranges. That way, blending and layering your design is made much easier.

Almost any paper or card stock will work: just make sure the pattern is not too busy or else the embroidery will not show up. Thinner papers can be used, as well as parchment paper and even acetate – just layer it over another piece to eliminate tearing between the pricked holes.

If you use photographs near the stitching, make sure the paper you use is acid-free.

My favourite papers to stitch on are the thicker 30 x 30cm (12 x 12in) scrapbook papers, which are often double-sided.

Embossing tools and light box

When embossing from the template, you will need to choose which elements of the pattern you want to use. The light box is thus essential to help you see through the paper.

I find the following procedure easiest: lay the template on the light box. Place the front of your card stock face-down on the template and secure with low-tack tape, avoiding where you need to emboss.

The light from the light box will show through the pattern. It is easier to move the template and card stock around the light box, than it is to move your hand at an awkward angle if you have taped the template down.

Most embossing tools are double-sided, so use the smaller ball for intricate shapes and the larger ball for the wide open shapes. A crisp edge is the goal in embossing, and to achieve this you must trace around the edges of the design illuminated by the light box. You do not need to use the tool in the middle of the design.

Embellishments

These are the icing on the cake! There are so many lovely items available and they are all such fun to use. It is difficult to offer advice as I like just about everything! However, while embellishments are very useful for making your embroidered stitching stand out, do use them in moderation, or the stitching will be overshadowed.

Metal, crystals and buttons would probably be my favourite embellishments, but three-dimensional paper embellishments and word stickers look great surrounded by a bit of embroidery, as do brads, craft jewels, paper flowers, jewellery findings and beads. Ribbons and glitter glue add a nice accent as well.

Building up your collection of embellishments over time will give you all sorts of options when finishing your embroidered work.

Other materials

You will need some other basic craft materials to complete the projects in this book. A **paper trimmer**, **scissors**, a **metal-edged ruler** and **craft knife** are needed for making everything the correct size.

Canvases, **acrylic paint**, **paintbrushes** and **quick crackle medium** are used to decorate the background for your wall art projects. **Die cutters** and **embossing folders** are used with the **die-cutting machine**, which is itself used in making the little albums.

Dry chalk, **liquid chalk cat's eye pads** and **sandpaper** are used for adding subtle colour to the projects. A **hole punch**, **tweezers**, **propelling pencil**, **eyelet tool** and **mat**, **wire** and **magnets** are all useful.

To keep everything in the correct position you will need **low-tack tape**, **double-sided tape** or **glue dots**, **3D foam pads**, **double-sided foam tape**, **a glue stick** and **strong craft glue** for embellishments.

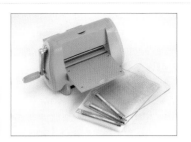

Tip

If you want to emboss the whole of the template, use a die-cutting machine with an embossing pad as this is very quick and simple.

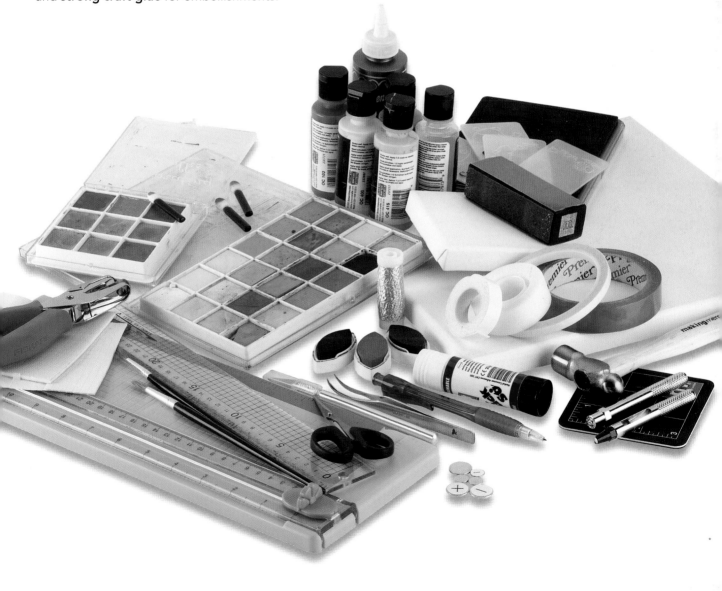

Basic techniques

There are only three basic techniques with which you need to be familiar to make these gorgeous projects; pricking, stitching and embossing. You can use all three design techniques on each project or you can use just one or two, depending on how much time and patience you have.

Look carefully at your chosen template before you begin, to decide which parts of the design you will use. There are lots of variations possible, so there is plenty of scope for creativity.

Pricking

Once you have decided on which design elements you wish to use, prick out the holes methodically so you do not miss any out. You can always hold the template and card up to the light to check if all the holes have been pricked before you remove the tape.

1. Place the paper on the pricking mat and place the template on the paper.

2. Use low-tack sticky tape to secure the template to the paper. Avoid covering the holes.

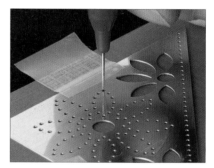

3. Push the point of the pricking tool through the hole in the template, then bring it out. Keep the tool vertical throughout.

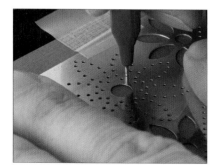

4. Continue pricking through the other holes of the design until you have pricked all the holes that you want.

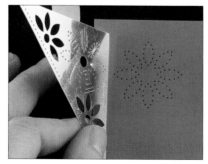

5. Carefully peel the low-tack tape away, and remove the template to reveal the pricking.

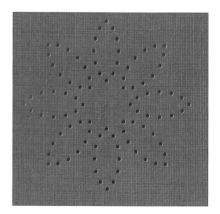

The completed pricking.

Stitching

Once the piece has the holes pricked out, you can begin the stitching. There are etched patterns on the template to give embroidery suggestions, so choose which one you prefer for each project. You can use different patterns on one project, or repeat the same one. You can also change the colours of thread for each pattern if you wish – just attach the thread at the back of your piece with sticky tape at the beginning and end. Once you are familiar with the template it is quite good to make up your own stitching pattern.

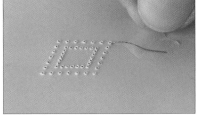

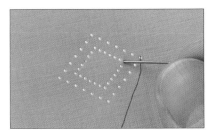

1. Cut a length of thread and take the end through the eye of a needle.

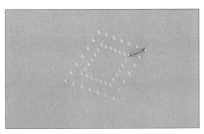

2. Take your pricked design and turn it over. Take the needle and thread through the first hole from the back to the front.

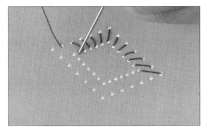

3. Pull the thread through from the back to the front, leaving a little thread on the back. Use a small piece of sticky tape to secure the thread to the card.

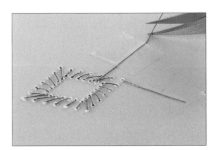

4. Turn the work over and place the needle in the next hole, following the design on the template.

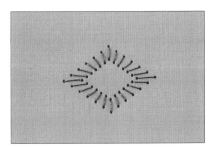

5. Draw the needle and thread through from front to back until the thread is taut. Do not pull it too tight, as the card can rip.

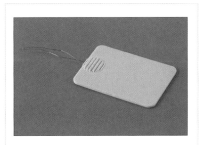

6. Continue working round the design, pulling the thread taut as you work. Remember to be gentle when tightening the thread.

7. When you have worked all the way round the design, take the thread through to the back, secure with sticky tape and cut off excess thread with scissors.

The completed stitching.

Tip

If you find threading needles difficult, use a needle threader.

Embossing

Embossing your design is not essential, but it does give an extra dimension that adds interest to your piece of work. You can emboss the whole design on the template using a light box or die-cutting machine. If you want to emboss only certain elements, you will need to use a light box and embossing tool.

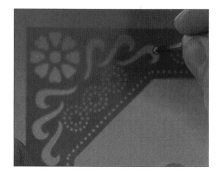

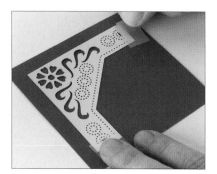

1. Lay the template on the paper and secure it with low-tack tape.

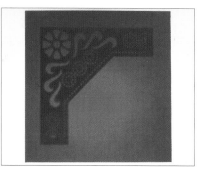

2. Place the template face-down on the light box.

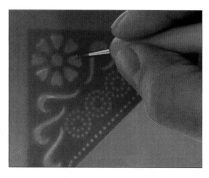

3. Use the embossing tool to trace around the edges of the silhouetted shapes. Use a firm pressure to get a crisp edge.

4. Work round the other parts of the design you wish to emboss.

5. Remove the template from the paper, being careful not to tear the paper as you remove the low-tack tape. Turn the paper over to see your completed embossing.

Tip

While you always prick from the front of your work, you always emboss it from the back.

Three simple greetings cards made with pricking, stitching and embossing. The embossing has been gently rubbed with sandpaper to alter the colour and give a decorative effect.

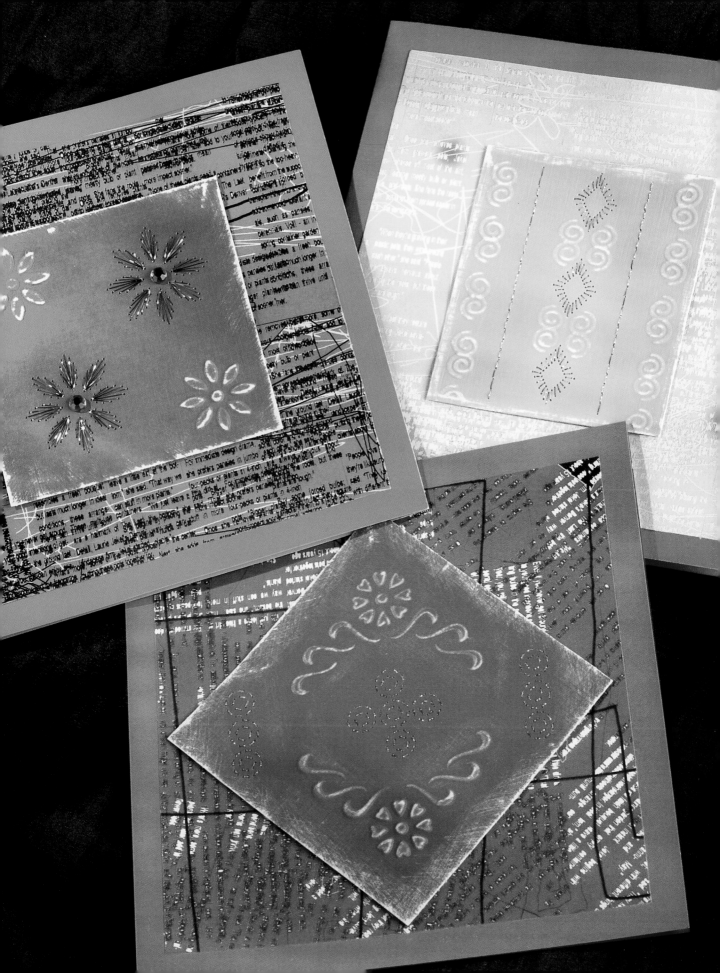

Blush Card

This card is fairly basic but it uses all three techniques of embossing, pricking and stitching. It is also a good example of choosing which elements from the template to use, and which to leave out. We will be using just the middle part, and flipping it around to create a square.

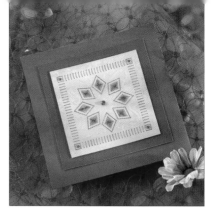

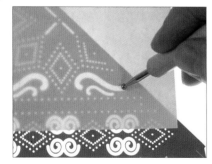

The template (number 500000/5105) used in this project.

1. Place the template on to the blush card so that the row of dots runs along the top and left edges, leaving a border approximately 0.5cm (¼in) from the edge. Secure with low-tack tape.

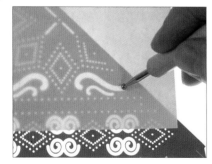

2. Place the card and template face-down on the light box as shown, and use the thick end of the embossing tool to emboss the first swirl on the bottom right.

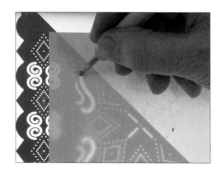

3. Emboss the rest of the swirls.

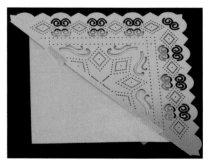

4. Remove the paper and template from the light box and place them face-up on the pricking mat.

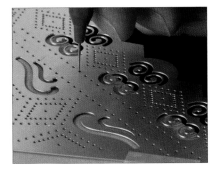

5. Use the pricking tool to prick along the long rows of the border on the right-hand side. Do not prick the additional holes at the corners.

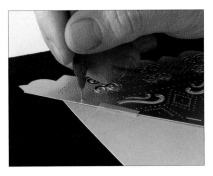

6. Work along the rows of the top border.

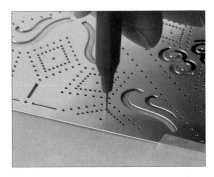

7. Prick all the holes in the half-diamond on the lower right.

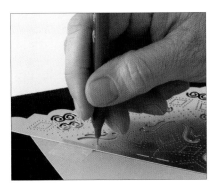

8. Work over the rest of the diamonds, pricking as you go. Finish by pricking the half-diamond on the lower left.

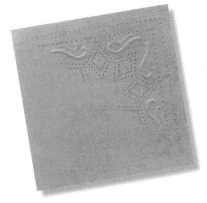

9. Carefully remove the template from the card to reveal the pricking and embossing.

10. To complete the other half of the card, align the template along the previously pricked holes at the bottom of the half-diamond.

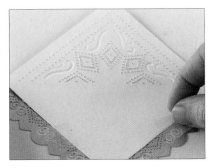

11. Use low-tack sticky tape to secure the template to the back of the card.

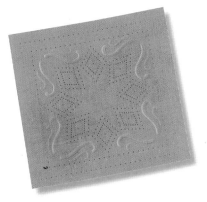

12. Emboss and prick as before to complete the design.

13. Thread a needle with purple thread and bring the needle through the outer point of the first diamond. Secure the thread on the back with some sticky tape, being careful not to cover the holes.

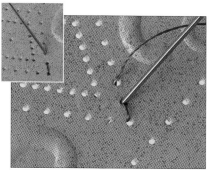

14. Working anti-clockwise, insert the needle into the next hole of the outer diamond and draw the thread through.

15. Bring the needle up through the next hole (see inset), draw the thread through and then take it back down the previous hole.

16. Pull the thread through and taut, then bring the needle up through the next hole.

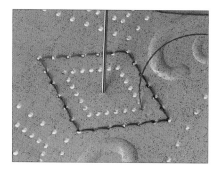

17. Continue working round the outer diamond (see inset) until it is completed, then bring the needle up in the first hole of the inner diamond.

18. Take the needle down through the central hole.

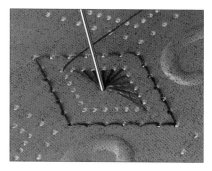

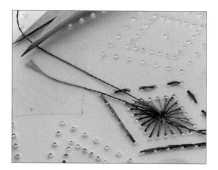

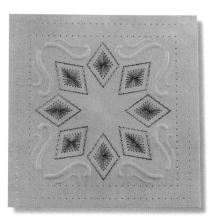

19. Working anti-clockwise, bring the needle up through the second hole of the inner diamond, then back down the central hole. Work round the inner diamond in this manner.

20. When you have completed stitching the inner diamond, secure the thread on the back with sticky tape and trim.

21. Work the other diamonds in the same way.

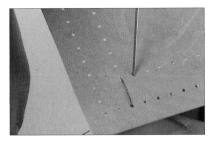

22. Thread a needle with the same thread and secure it on the back of the piece with tape. Bring the needle up from the inside corner of the border and down directly below. Draw the thread taut, then bring the needle up on the inside row, to the right of where you started.

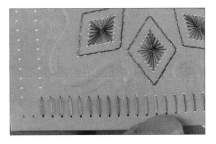

23. Work along the border in the same way. When you reach the corner, bring the needle up in the top right hole of the corner pricking.

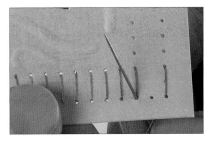

24. Take the needle down through the bottom right hole and up through the bottom left hole as shown.

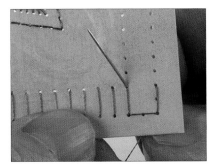

25. Take the needle down through the bottom right hole, and up through the top left hole of the corner.

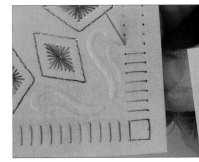

26. Complete the corner by taking the needle down the top right hole, then bring it up through the first hole of the inner border and work the edge as before.

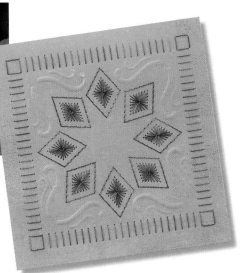

27. Work all the way round the border in the same way, then secure and trim the thread.

28. Put foam tape on the corners and centre of the back of the piece of bright pink card.

29. Fold the purple card in half, remove the backing from the foam tape and place the pink card on the front of the purple card.

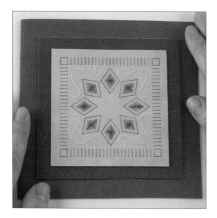

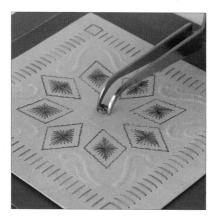

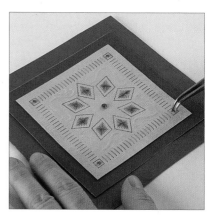

30. Put foam tape on the back of the embroidered piece, remove the backing and place it centrally on the bright pink card.

31. Use the tweezers to place a sticky-backed craft jewel in the centre of the diamond pattern.

32. Place star-shaped sticky-backed craft jewels in the corners of the diamond pattern.

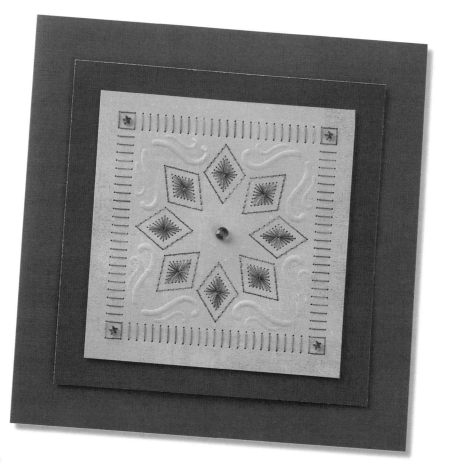

The finished card.

Opposite:
The gorgeous variegated thread, changing between pink and purple, makes this blushing beauty a good card for a special person or important occasion.

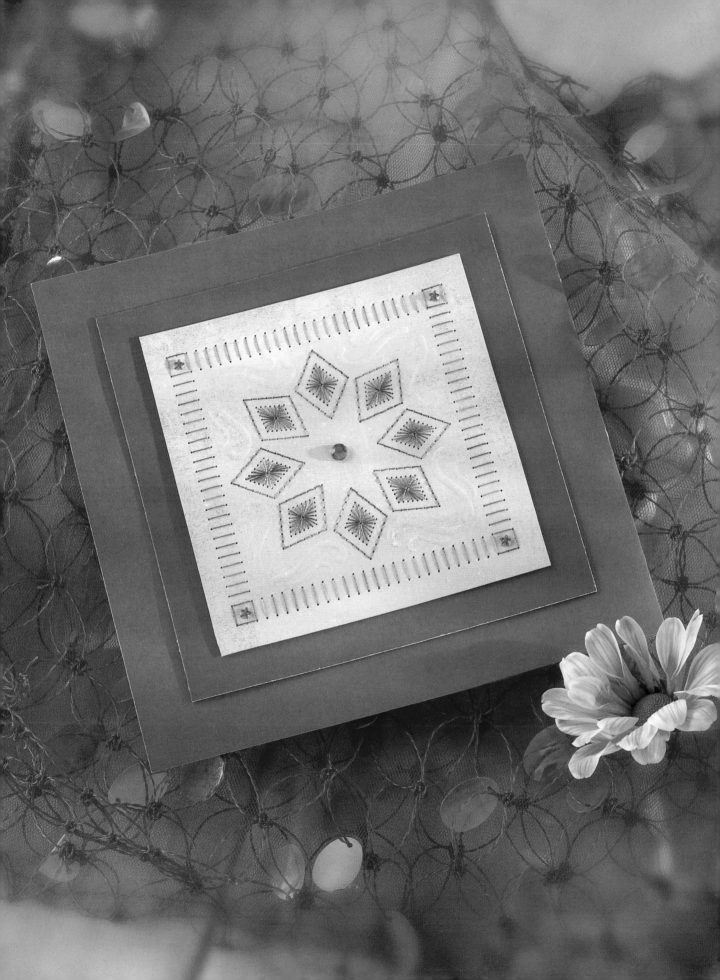

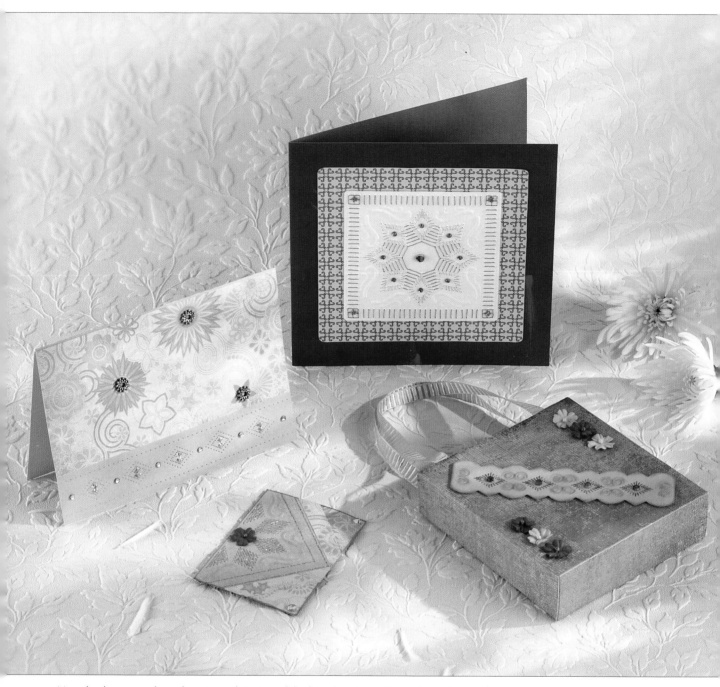

Use the brass embroidery template to add a border along the edge of a card, to make a decorative strip on a bag, or to make a special artist trading card.

The larger card uses the same embossing and pricking, but two different coloured threads have been used and different etched stitching guides were used.

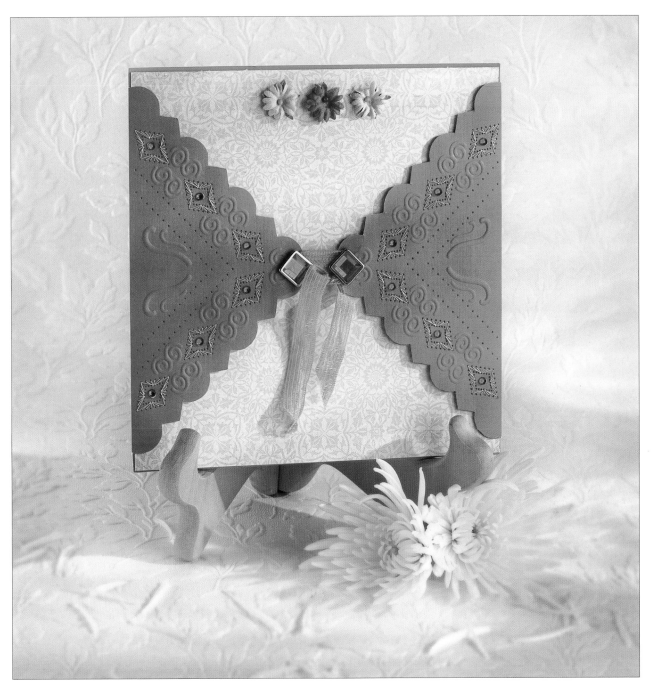

Here I have used the template along a fold line to make an interesting closure, which has been secured with decorative brads and ribbon.

This example could also be used for a mini album.

Eastern Promise

This card demonstrates that you can use your templates to suit any occasion: all you need to do is change the paper, thread and embellishments. Double-sided scrapbook paper works well for embroidered cards as one side is plain to show off the stitching to best effect, while the other side is patterned, making the inside of the card interesting as well. Metal jewellery findings make this project different and eye-catching.

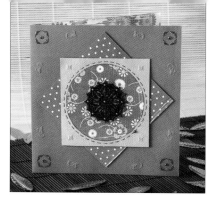

The template (number 500000/5113) used in this project.

You will need

- Double-sided flower-patterned card 30 x 15cm (12 x 6in)
- Polka-dot card 10 x 10cm (4 x 4in)
- Brown flower-patterned card 9 x 9cm (3½ x 3½in)
- Buff card 9 x 9cm (3½ x 3½in)
- Pricking tool and mat
- Light box
- Embossing tool
- Copper metallic thread and needle
- Double-sided foam tape and 3D foam pads
- Pencil and scissors
- Copper jewellery embellishment
- Low-tack sticky tape
- Five craft jewels
- Tweezers
- Craft knife and cutting mat

1. Fold the flower-patterned card in half so that the flower pattern is on the inside.

The inside of the double-sided card.

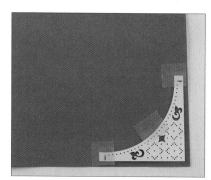

2. Open the card out and secure the template in the bottom-right corner with low-tack tape. Leave a narrow border at the side and bottom.

3. Place the card and template face-down on the light box and emboss the fleur-de-lys design from the template.

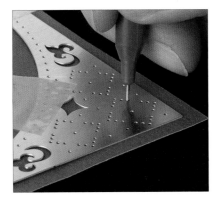

4. Remove the card from the light box and place it face-up on your pricking mat. Prick out the square in the corner.

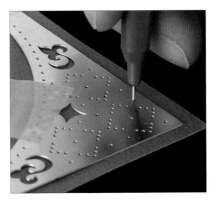

5. Prick out the centre hole and the four outer holes that surround the square.

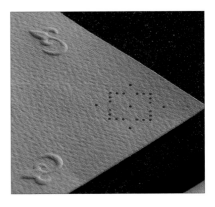

6. Carefully remove the template to reveal the corner design.

7. Repeat the embossing and pricking on the other corners.

8. Thread a needle with copper thread, then secure it on the back with low-tack sticky tape at the edge, just below the embossing.

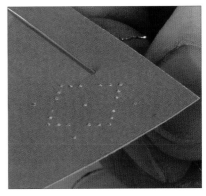

9. Bring the needle up through the outer top right hole of one of the pricked motifs.

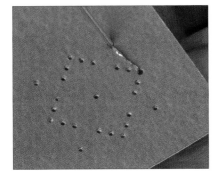

10. Take the needle down the right-most hole of the motif, then back up the outer hole on the top right.

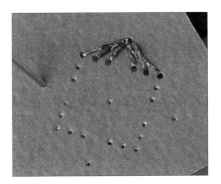

11. Work along the row of holes, coming up the outer hole each time. Once you reach the end of the row, bring the needle up the outer hole on the top left.

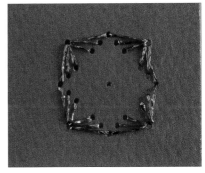

12. Repeat this process on the other sides of the motif.

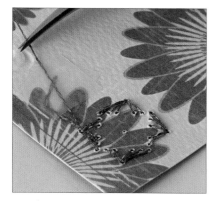

13. Secure the thread on the back with sticky tape, and trim the excess thread.

14. Repeat the embroidery on the other three motifs.

15. Apply foam tape to the corners and centre of the back of the polka-dot card.

16. Remove the tape backing and place the polka-dot piece diagonally on the front of the embroidered card.

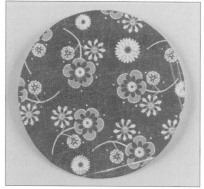

17. Cut an 8cm (3¼in) circle from the brown flower-patterned card.

18. Use a pencil to trace round the circle on to buff card.

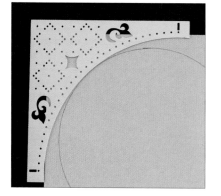

19. Put the buff card on the pricking mat, then place the template so that its edge touches the circle.

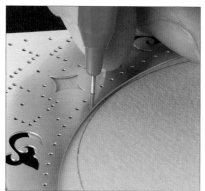

20. Prick the hole in the centre, directly below the point of the diamond embossing guide.

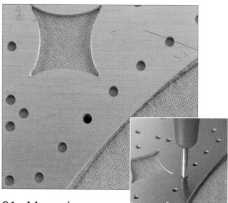

21. Move the template clockwise round the circle so that the pricked hole is visible through the next hole in the template, then prick the hole below the point of the diamond.

22. Continue round the circle until you have pricked a complete ring of holes round the circle.

23. Place the piece on to a cutting mat and use a craft knife to cut the circle out.

24. Use the brass template with the light box and embossing tool to emboss a diamond in each corner of the piece.

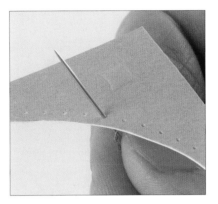

25. Thread a needle with copper thread, secure the thread on the back and bring the needle up below one of the diamonds.

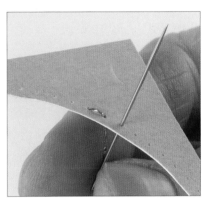

26. Working clockwise, take the needle down through the next hole, then up through the following hole.

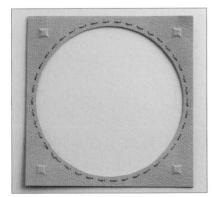

27. Work all the way around the circle in this way. When you reach the end, take the needle through the starting hole, secure the thread on the back and trim the excess thread.

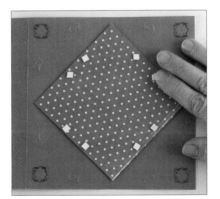

28. Put 3D foam pads on the polka-dot diamond as shown.

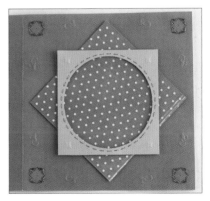

29. Remove the backing from the 3D foam pads and place the buff piece on top.

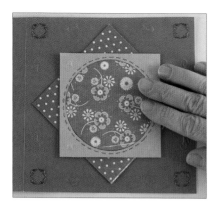
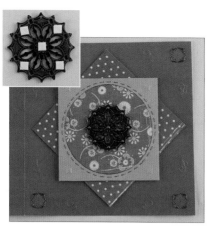

30. Put foam tape on the back of the brown flower-patterned circle and place it in the middle of the buff card.

31. Put 3D foam pads on the back of the copper decoration (see inset), then remove the backing and place it in the middle of the brown flower-patterned circle.

32. Place a craft jewel in the middle of each embroidered corner and on the join in the copper thread of the buff card.

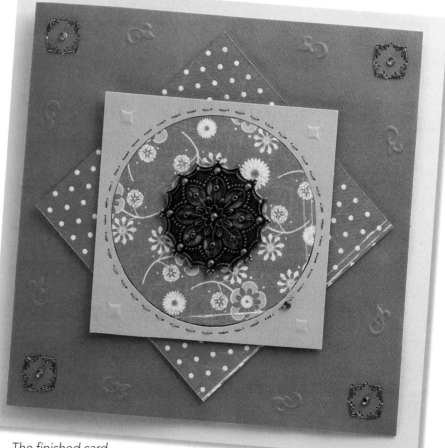

The finished card.

Opposite:
Sleek and unfussy, this design is suitable for a male or female recipient – just change the papers to suit the occasion.

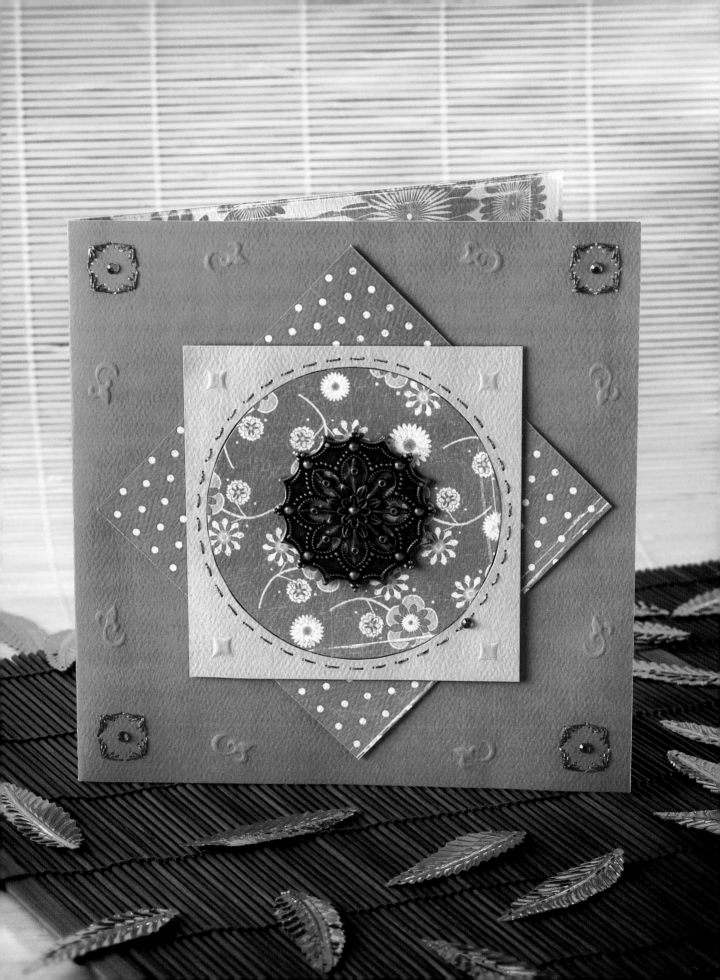

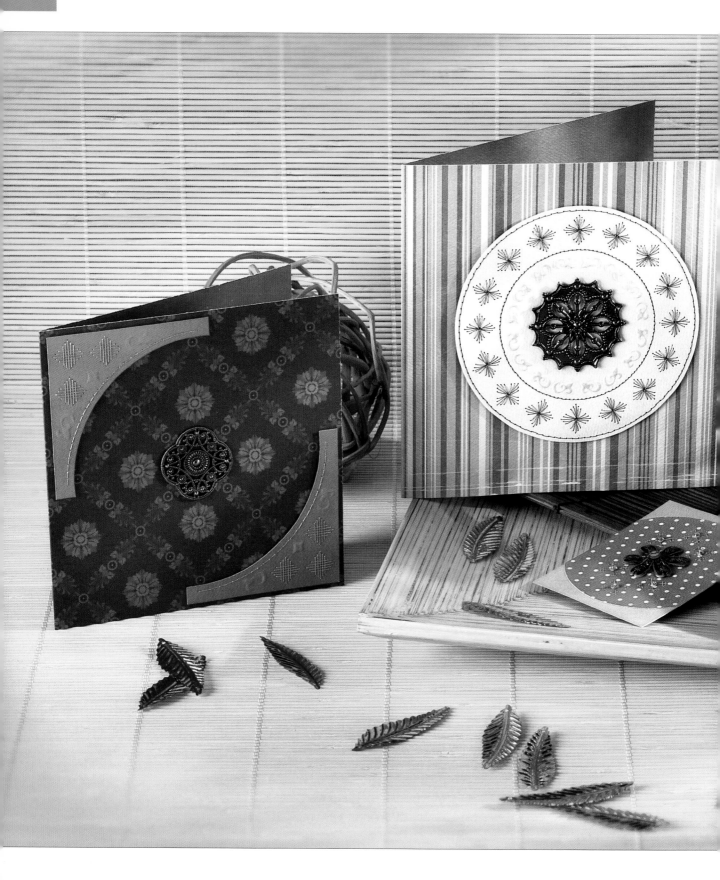

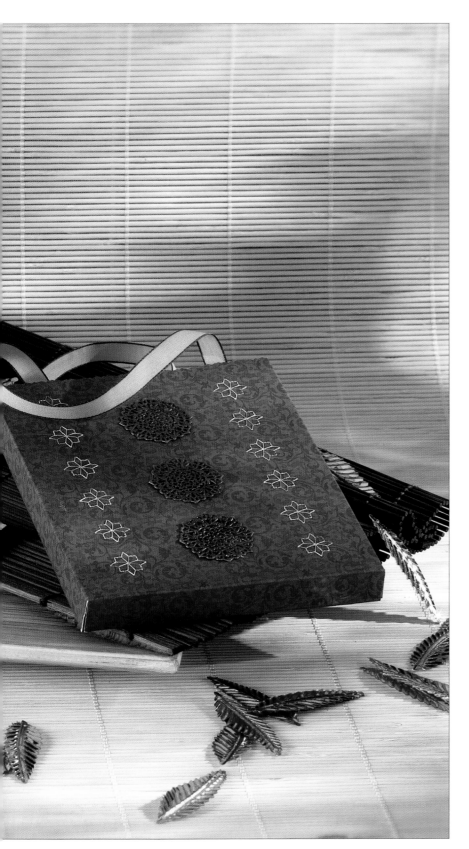

Here the embroidered stitches give an interesting definition to metal embellishments. The template has been used to make corners, a full circle, borders at the edge of a CD gift box, and to decorate an artist trading card.

Pink chalk has been used to add a touch of colour to the embossing on the central card.

Crystal Chic Card

The simplicity of this card makes it very elegant, and suitable to give to someone special for any occasion. The crystal jewels catch the light and add a rainbow of colour to a monochrome palette.

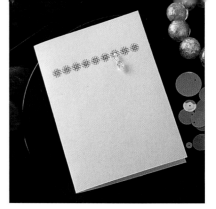

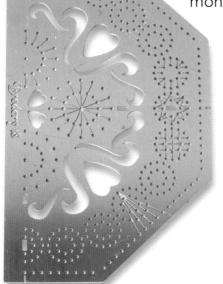

The template (number 500000/5118) used in this project.

1. Fold the A5 pearlescent card in half.

You will need

- A5 sheet of white metallic pearlescent card
- A5 sheet of thin white card
- Black holographic thread and needle
- Pricking tool and mat
- Low-tack tape
- 30cm (12in) thin silver wire
- Large, medium and small crystal beads
- Pencil and ruler
- Clear adhesive

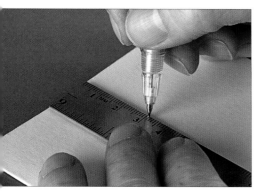

2. Make a faint pencil mark 3cm (1¼in) from the top of the card.

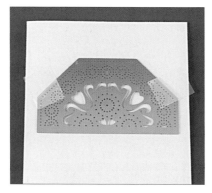

3. Place the template so that you can see the pencil mark through the top hole of the middle circle, and secure the template with low-tack tape.

Close-up of the template. Note the pencil mark in the top centre of the template.

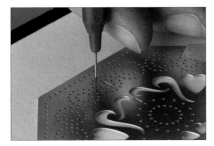

4. Open the card out and place it on the pricking mat, then prick the inner and outer rings of the middle circle.

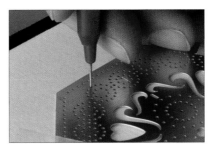

5. Prick the inner and outer rings of the circle to the left.

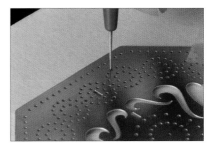

6. Prick the inner and outer rings of the circle to the right in the same way.

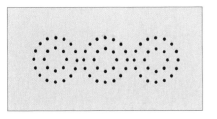

7. Remove the template carefully to reveal the pricked circles.

Tip

Use the holes visible through the left-hand circle on the template to ensure that the template is in the correct position.

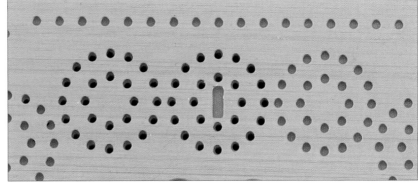

8. Replace the template so the middle circle of the template is aligned with the right-most pricked circle.

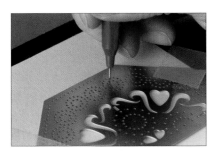

9. Prick the circle on the right.

10. Continue moving the template to the right (aligning it with the previous circles) and pricking until you have six pricked circles.

11. Repeat this process to the left until you have nine circles on the card.

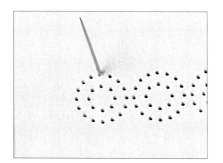

12. Thread a needle with black holographic thread, secure it on the back of the card with sticky tape and bring it up through the top hole of the left-most circle.

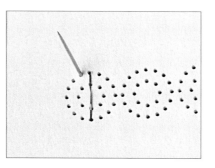

13. Take the needle down through the bottom hole of the circle, then up through the hole immediately to the left of the top hole.

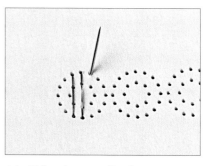

14. Take the needle down through the hole to the left of the bottom hole, then up through the hole immediately to the right of the top hole.

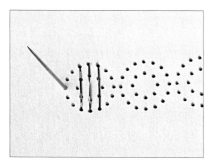

15. Take the needle down through the hole to the right of the bottom hole, then up through the left-most hole.

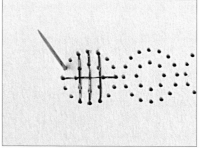

16. Take the needle down through the right-most hole, then up through the hole immediately above the left-most hole.

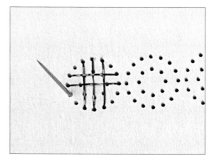

17. Take the needle down through the hole above the right-most hole, then up through the hole immediately below the left-most hole.

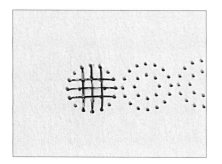

18. Take the needle down through the hole below the right-most hole to complete the embroidery on the circle.

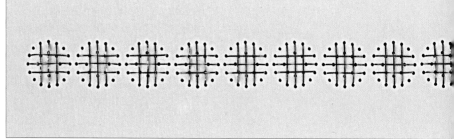

19. Work the other circle motifs in the same way. Secure the thread on the back with sticky tape and cut off the excess.

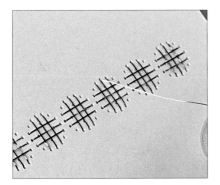

20. Carefully push the wire through the top-most hole of the third circle from the right, and secure it on the back with sticky tape.

21. Thread the first of the smaller crystals on to the wire.

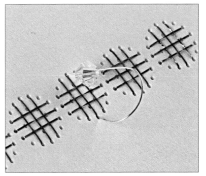

22. Take the wire through the bottom-most hole and draw it through, trapping the crystal.

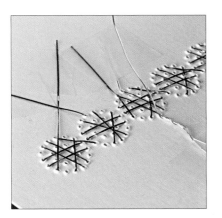

23. Turn the card over, double the wire over, twist it, and secure it with sticky tape.

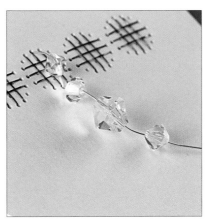

24. Feed the loose end of the wire through the bottom-most hole of the circle, and thread a small crystal followed by a large crystal and another small crystal on to the wire.

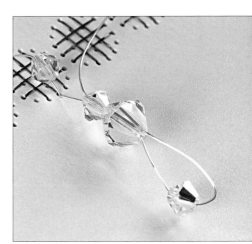

25. Take the wire back around the bottom-most small crystal and back through the large crystal and the smaller crystal above it.

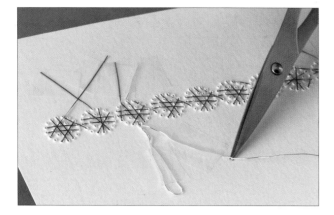

26. Take the wire through the hole at the bottom, then secure it at the back with sticky tape. Trim the excess wire.

27. Take a sheet of thin card, fold it in half and glue it to the inside of the card with the clear adhesive to cover the working.

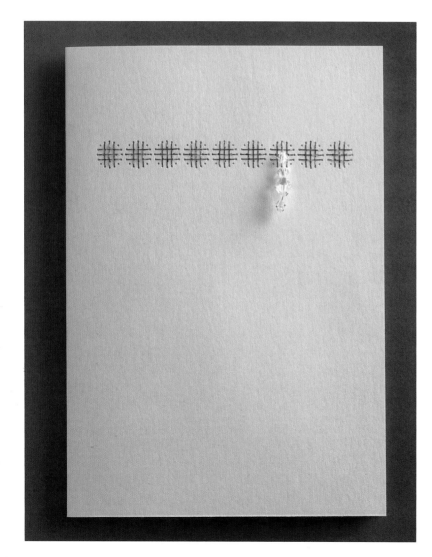

The finished card.

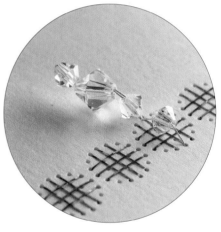

Opposite:
Make an elegant statement with this monochrome card, accented with crystal to catch the light. An ideal wedding invitation!

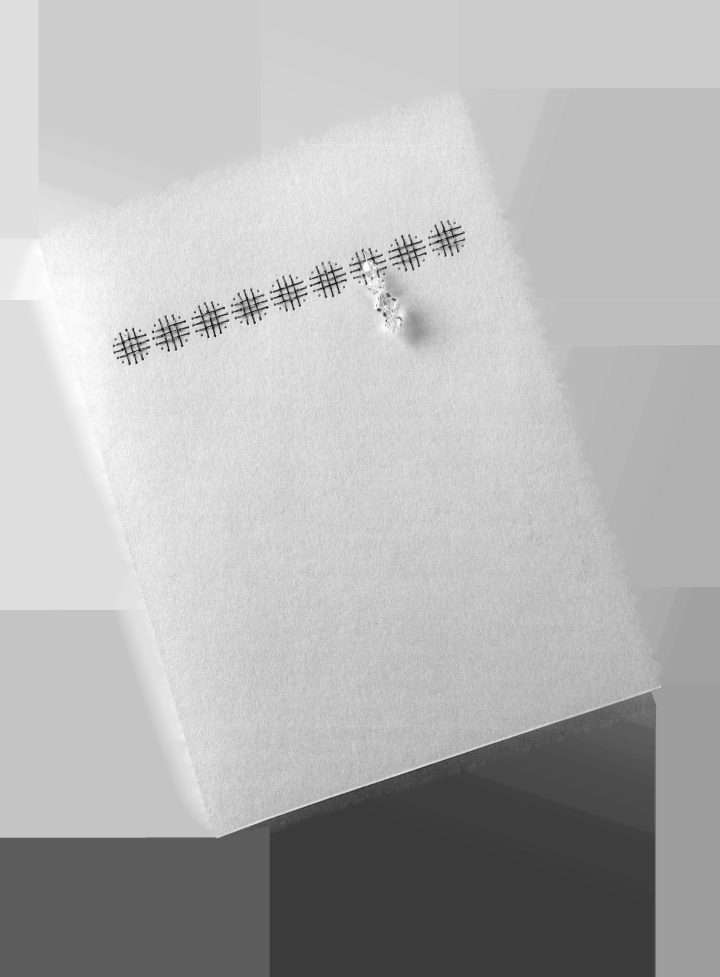

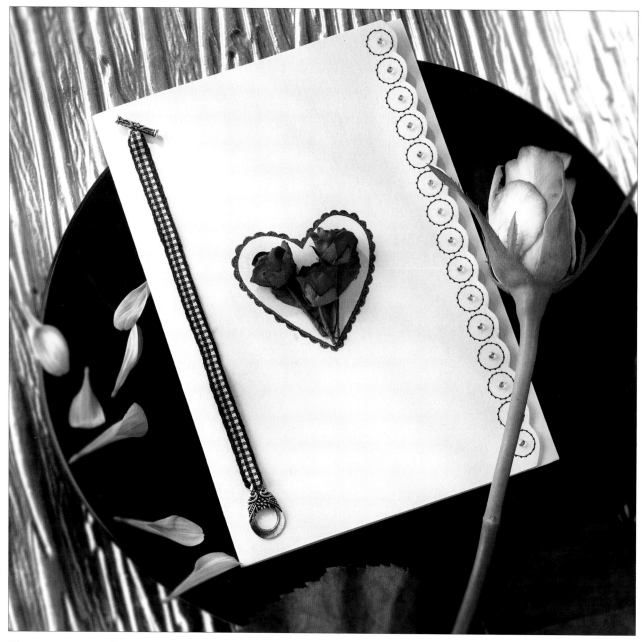

The repeating circles make the border of this card very smart.
Cut around the circles with scissors to create a scalloped edge.

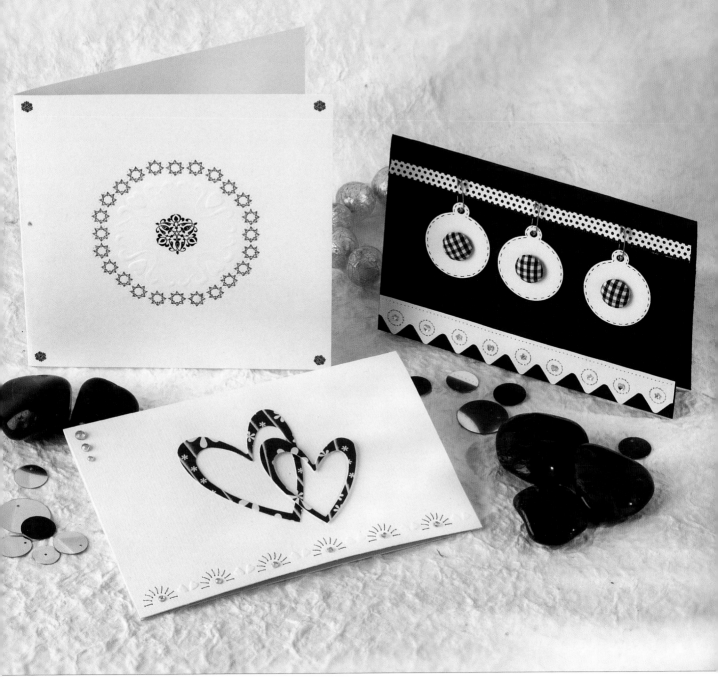

By varying the stitches from this template, you can make a decorative feature using half circles or eight-pointed stars: trim a zigzag border, add embroidered circles at each point, then make a row of pricked holes.

Spring Bag

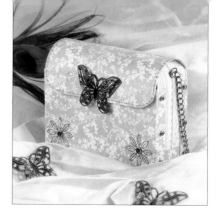

This cute little bag is actually big enough to store cardmaking or scrapbooking tools and embellishments, or even to keep your make-up organised.

The embroidery is quite simple but adds character and personality. It is cheap and easy to make, and you could even use it as a handbag if you make sure you varnish the paper first.

Note

The patterns for this project are on pages 76–77.

The template (number 500000/5115) used in this project.

You will need

- Green patterned paper 30 x 30cm (12 x 12in)
- Striped paper 30 x 30cm (12 x 12in)
- Ruler and embossing tool
- Scissors and pencil
- Pricking tool and mat
- Sticky tape, double-sided sticky tape and low-tack tape
- Needle and black holographic thread
- Glue stick
- 4 large brads and 12 small brads
- 5 pairs of magnets
- Glaze pen and metal butterfly embellishment
- 30cm (12in) chain

1. Transfer pattern I (see page 76) on to green paper and cut it out to make the framework of the bag.

2. Transfer pattern II (see page 77) on to the striped paper and cut it out.

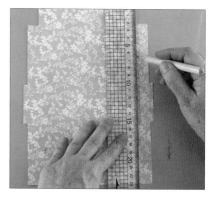

3. Following the pattern, use a ruler and the fine end of the embossing tool to score along the dotted lines of the green paper.

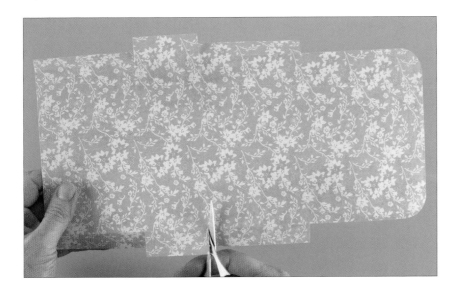

4. Following the pattern carefully, use scissors to cut into the solid lines to create tabs.

5. Transfer pattern III (see page 77) to the striped paper twice.

6. Cut the shapes out, and repeat with the green paper.

7. Place the green paper framework on to the pricking mat and use low-tack tape to secure the template to the paper as shown. Use the fold lines to align the template in the corner.

8. Use the pricking tool to prick the flower design in the corner.

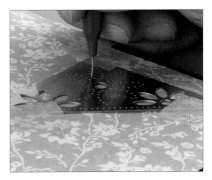

9. Move the template to the opposite corner and prick out the flower design.

10. Thread a needle with black holographic thread, secure it on the back, and bring it up through the point of one of the petals of the left-hand flower pricking.

11. Working clockwise, take the needle down the next hole, then up through the third hole.

12. Take the needle back down through the second hole, then up through the fourth. This creates a solid line of embroidery.

13. Work round the whole petal in the same way.

14. Bring the needle up through the starting point (see inset), then down through the opposite point of the petal.

15. Work round the other petals of the flower motif, then secure the thread on the back with sticky tape, and trim any excess.

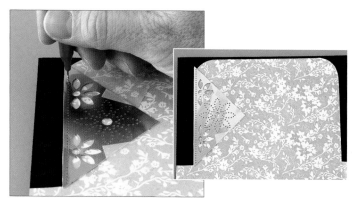

16. Repeat the working on the other flower.

17. Secure the template to the top flap of the green card (see inset), then prick a row of holes down the side to the corner.

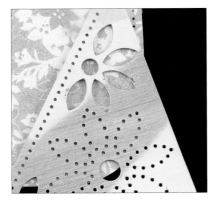

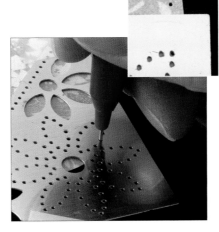

18. Remove the template, then align the point of one of the petals with the last hole you pricked.

19. Prick halfway along the curve of the petal, then move the template so the point of the petal is aligned with the last point pricked (see inset).

20. Work around the corner, pricking and moving the template until the curve is completed.

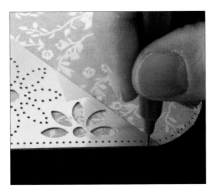

21. Align the straight edge with the last pricked point of the curve, secure the template and prick the line.

22. Prick the other corner and side of the flap in the same way.

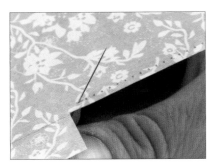

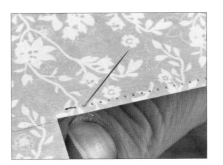

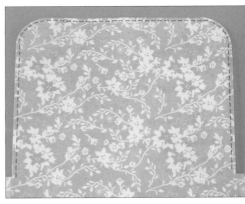

23. Thread a needle with black holographic thread, secure it on the back and bring the needle through the hole at the end of the straight edge of the flap.

24. Take the needle down the second hole and up through the third hole of the flap.

25. Work in this way around the whole flap, then secure and trim the thread. Put the green piece to one side for the moment.

26. Run double-sided tape round the sides and down the centre of the back of the striped piece. Remove the backing paper.

27. Stick the striped piece in the middle of the back of the green piece as shown.

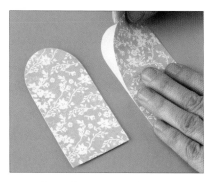

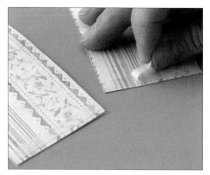

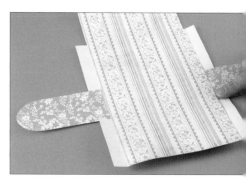

28. Place the striped flaps face-down, then use a gluestick to attach the green flaps to the back of them.

29. Run double-sided tape along the bottom edge of the striped side of the flaps and remove the backing paper.

30. Attach the flaps to the middle tabs of the assembled framework, striped side-down as shown.

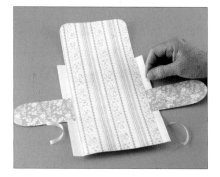

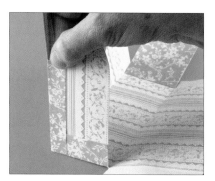

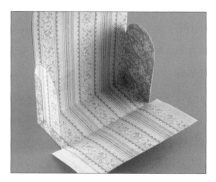

31. Run double-sided tape along the edges of the other tabs and remove the backing.

32. Fold along the scorelines of the framework, then lift one of the flaps up and secure it with the tab on the side.

33. Lift the other flap up and secure it with the tab on the side.

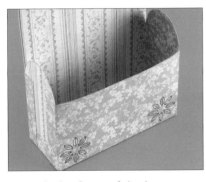

34. Lift the front of the bag up and fold the tabs around the flaps to secure the front in place.

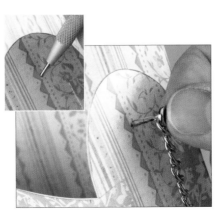

35. Use the pricking tool to make a hole in the centre of the top of the flap (inset). Thread a brad through the end of the chain, and insert the brad into the hole.

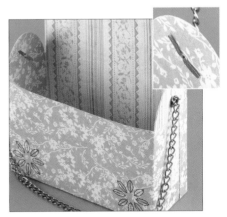

36. Open the brad out (see inset), and repeat on the other side to make a chain handle for the bag.

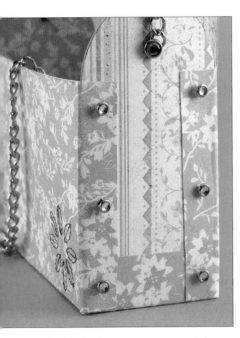

37. Make holes with the pricking tool and run decorative brads down the sides to help secure the flaps of the bag.

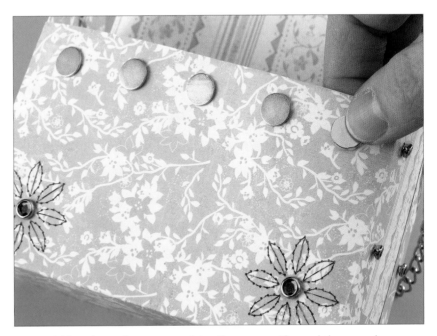

38. Add brads to the centre of the flower motifs, and then peel the backing from five magnets and stick them to the top of the front of the bag.

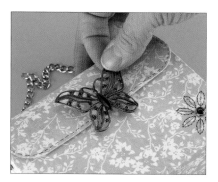

39. Peel the backing from the other half of the magnets and stick them to the top of the flap, making sure that they attract the magnets on the top of the front of the bag.

40. Use a glaze pen to colour the crystals on the butterfly decoration, and allow to dry.

41. Fold the flap of the bag over and place the butterfly on the front of the bag to finish. The magnets will hold it in place.

The finished bag.

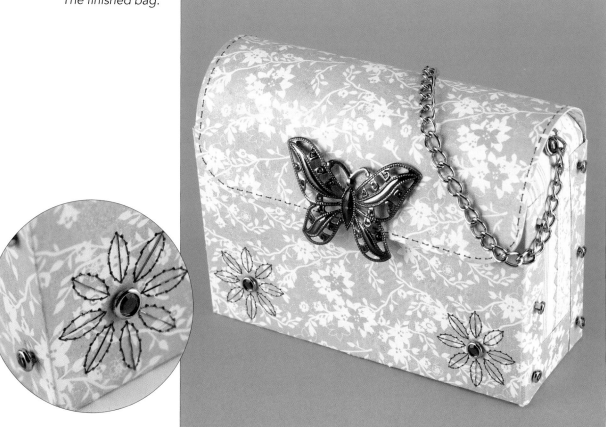

With this bag you can add some butterfly chic to your work space for organising bits and pieces.

It could also be used as a clever way to wrap a present, or even as a summer bag for the bare essentials when you go out.

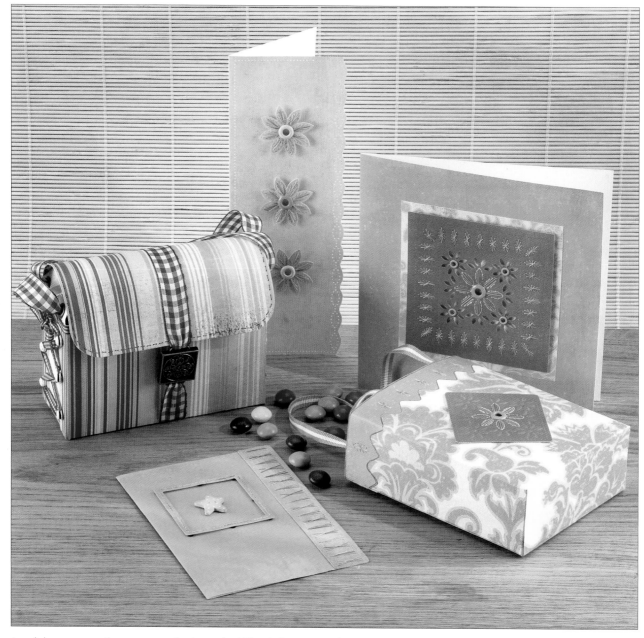

Look how versatile one template can be! Use it for a straight line of stitching around the flap of a bag; embroider the daisy pattern on to card and cut out the flower or use it for the centre of a piece and stitch around the edge (this shows off rainbow thread beautifully).

It is also very nice to create a frame around an embellishment or to add a simple stitched border.

Opposite:
This embroidery template is charming in its simplicity. Use it to make corners for a card, to decorate the flap of a bag, or as an aperture for a metal embellishment.

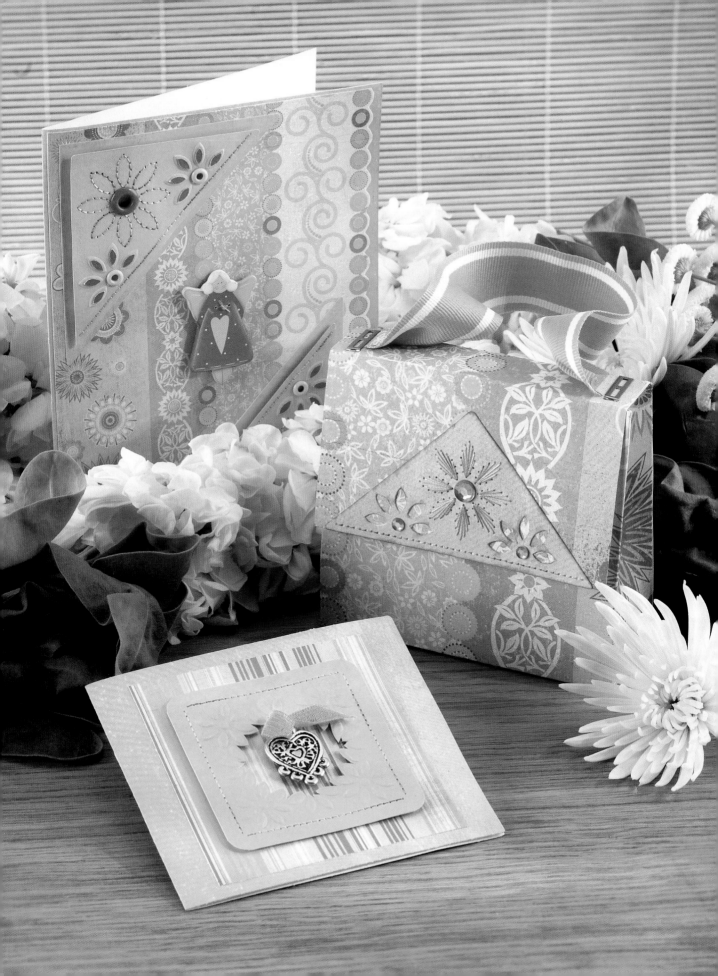

Collage Sweethearts

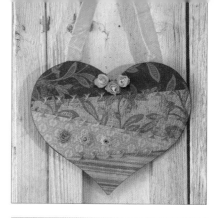

I love hearts in all shapes and sizes, and these designs, used with pretty embroidery and a charming mix of papers, will look lovely hanging from a window or on a peg for decoration. Omit the foam in the middle and they would also be suitable for scrapbooking and cardmaking.

The template (number 500000/5112) used in this project.

You will need

- 30 x 30cm (12 x 12in) sheets of pink, red patterned, gingham, striped, blue and leaf-patterned card
- A4 craft foam sheet
- Pink variegated thread and needle
- Pencil, ruler and scissors
- Pink velvet ribbon 40cm (15¾in)
- Pricking tool and mat
- Low-tack tape
- Three paper roses and three crocheted flowers
- Tweezers
- Strong craft glue

The pattern used in this project, reproduced here at three-quarters of the actual size. You will need to enlarge this pattern by 133 per cent on a photocopier for the correct size.

1. Transfer the pattern to pink card and cut round the outside.

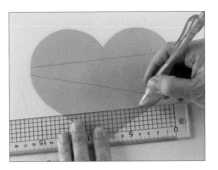

2. The heart is not quite symmetrical, so ensure that the larger side is on the right before drawing the lines on the front, as shown on the pattern.

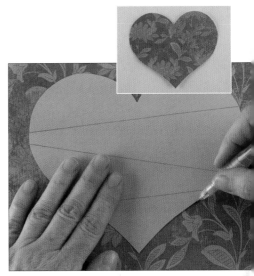

3. Place the pink heart face-up on to red patterned paper and draw round it with a pencil. Cut the heart out (see inset) and set it to one side.

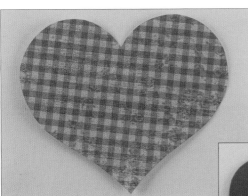

4. Place the pink heart face-down on to gingham paper, draw round it with a pencil and cut it out. Set it to one side.

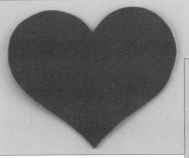

5. Finally, place the pink heart face-up on to the foam sheet, draw round it with a pencil and cut it out. Set it to one side.

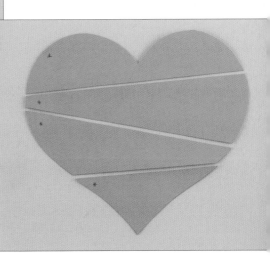

6. Cut the pink heart into four pieces along the lines, and mark each piece with a star so that you know which side is the front.

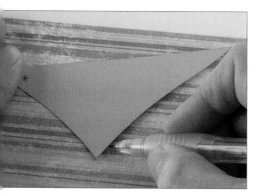

7. Trace round the bottom piece of the pink heart on to the striped paper.

8. Use the scissors to cut out the traced shape.

9. Trace the next piece of the heart on to blue paper and cut it out.

10. Trace the third piece of the heart on to the leaf-patterned paper and cut it out.

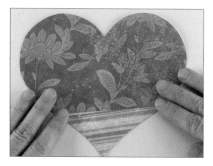

11. Use craft glue to attach the striped part to the bottom of the red heart.

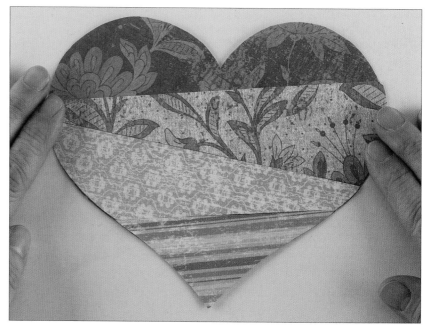

12. Glue the blue and flower-patterned pieces to the heart.

13. Put the prepared heart on to the pricking mat. Line up the pricking template on the heart so that the join between the red and leaf-patterned paper parts is visible in the diamond-shaped holes (see inset). Secure it in place with low-tack tape.

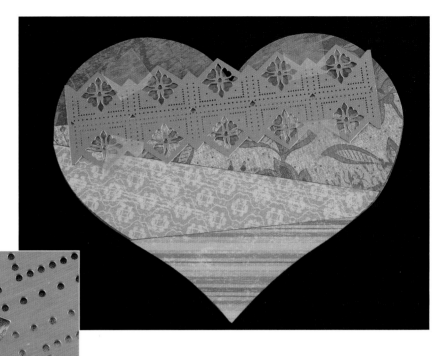

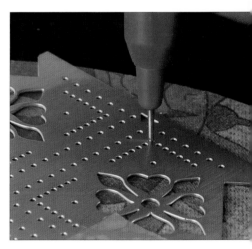

14. Prick the seven holes of the L-shaped motifs that are parallel to the join between the red and flower-patterned papers.

15. Work along the ten groups of seven holes until you reach the end of the template.

16. Prick all ten of the corresponding rows of holes below the join.

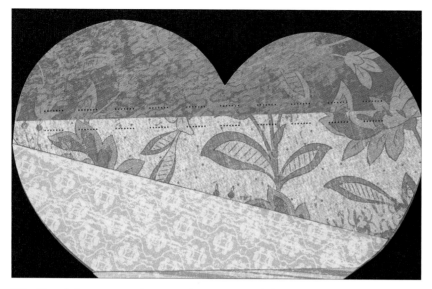

17. Carefully remove the template to reveal the repeating pattern of holes as shown.

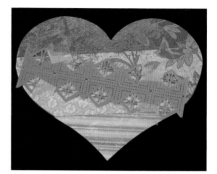

18. Place the pricking template on the join between the flower-patterned and blue paper parts as before, and secure with low-tack tape.

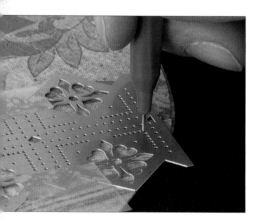

19. Prick the repeating pattern as before, and remove the template from the heart.

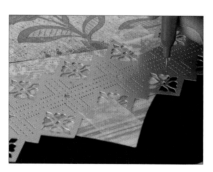

20. Replace the template on the final join and prick the pattern once more. Remove the template.

21. Thread your needle with pink thread, secure it on the back with sticky tape, and bring the needle through the first hole you pricked on the top row.

22. Take the needle down through the seventh hole of the row below, then up through the second hole of the top row.

23. Take the needle down through the sixth hole of the row below, then up through the third hole of the top row.

24. Continue working in this way until the motif looks like the picture.

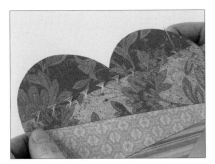

25. Work all ten groups of the top row of motifs.

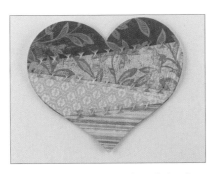

26. Work the second and third rows of motifs, and secure the thread on the back. Cut off any excess thread.

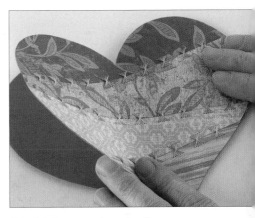

27. Make sure that the foam heart is the correct way round and use craft glue to attach the embroidered heart to the green foam heart.

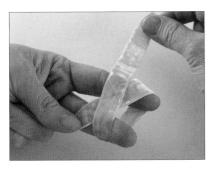

28. Make a loop with the ribbon around your fingers.

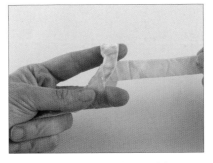

29. Take the end of the ribbon through the loop.

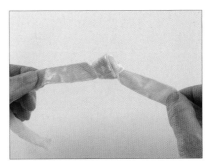

30. Slip the loop off your fingers and pull each end to make a knot.

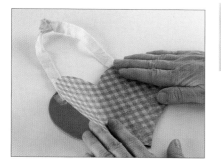

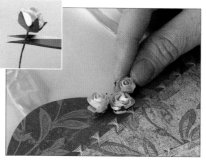

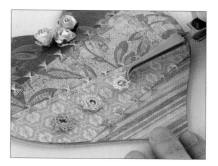

31. Tape the ends of the ribbon to the back of the foam heart so the knot is central, then use a glue stick to attach the gingham heart to the back of the foam.

32. Cut the stems from three paper roses (see inset) and use strong craft glue to attach the roses to the top of the front of the heart.

33. Use tweezers and strong craft glue to attach three crocheted flowers to the heart to finish the collage.

The completed collaged decoration.

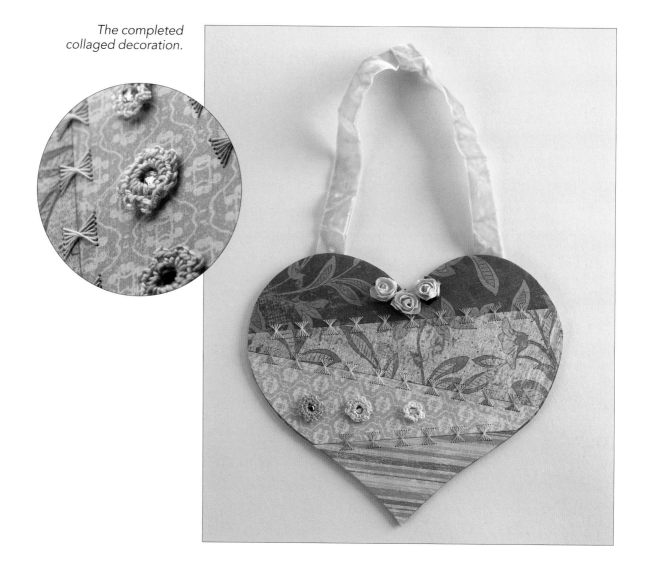

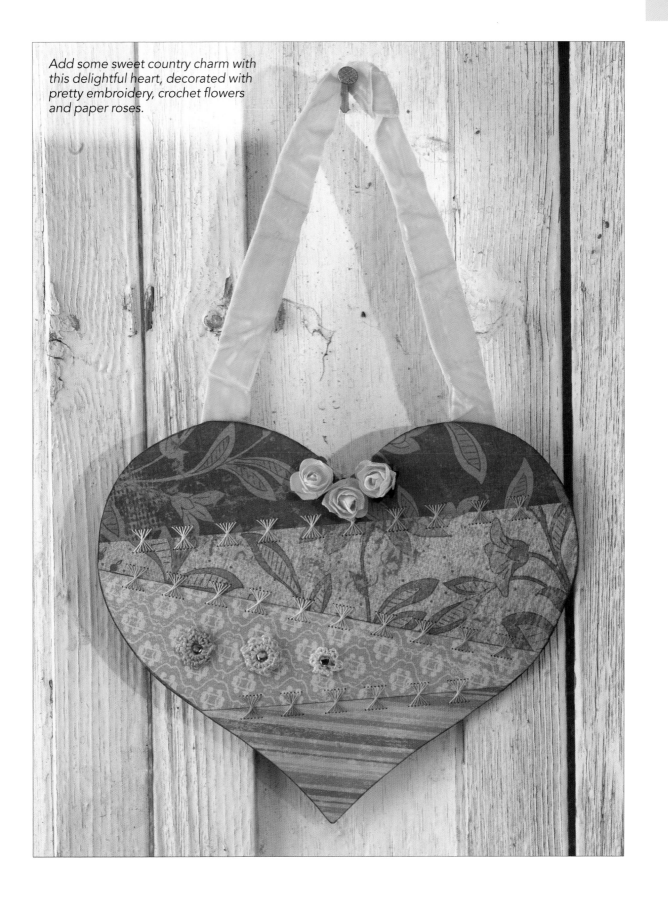

Add some sweet country charm with this delightful heart, decorated with pretty embroidery, crochet flowers and paper roses.

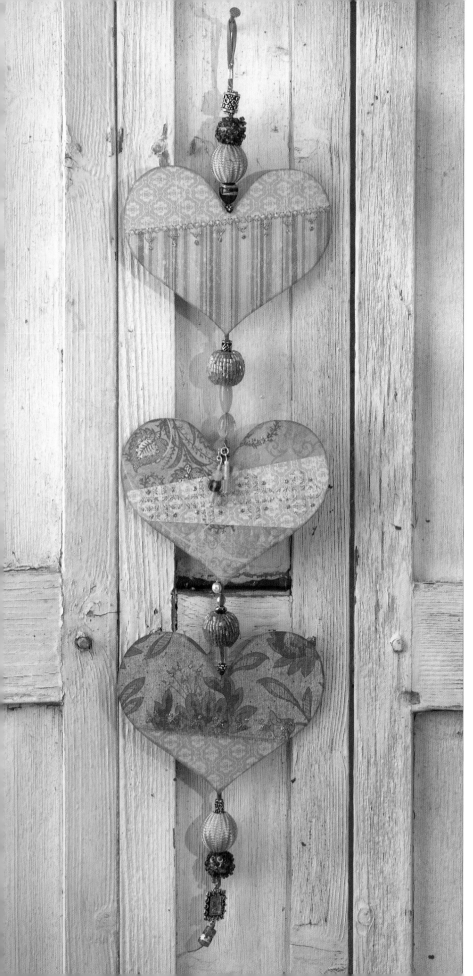

Make three hearts from the template on page 78 and add a variety of stitches on coordinating papers. Thread the hearts, along with beads between them, on to leather cord to make a decorative wall hanging.

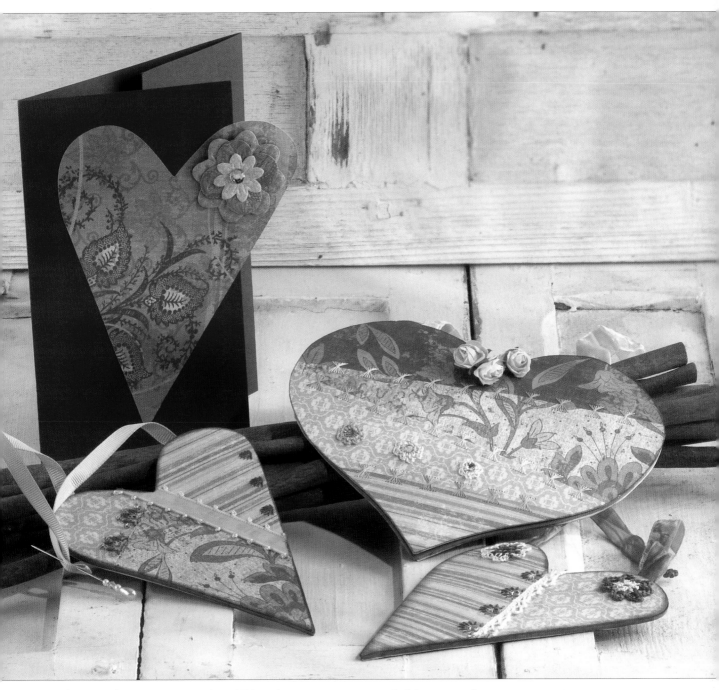

Use the templates on pages 50 and 79 with vintage papers and ribbon to make hanging hearts, or a card. Thicker threads will add dimension to your work.

Memory Album

This adorable little album is bright and cheerful and ready to be shown off with cute pictures added. The die-cutting machine makes assembly quick and easy, and the embroidery stitches add a special quality to your work.

The template (number 112307/7003) used in this project.

1. Use the paper trimmer to cut two 25 x 13cm (10 x 5in) sheets of paper from the tartan paper sheet.

2. Place the album cover die on the bottom cutting pad in the die-cutting machine, foam side up.

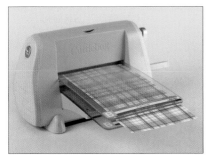

3. Lay both tartan sheets on the album cover die, then place the upper cutting pad on top.

4. Run the paper through the die-cutting machine to give you the front and back covers of the album.

5. Repeat the process using the album insert die with a sheet of light blue card, a sheet of dark blue card and a sheet of red card.

6. Run a line of double-sided tape down the front album cover, next to the holes.

7. Remove the backing and place a 10cm (4in) length of wavy ribbon on the tape.

8. Align the holes of the pages and covers. Make sure that the back cover has the tartan facing outwards.

9. Push two button brads through the holes and open the brads at the back to hold the book together.

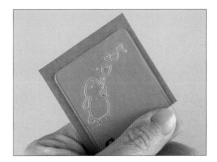

10. Cut a piece of red card 6 x 6cm (2¼ x 2¼in) and put it in the embossing folder.

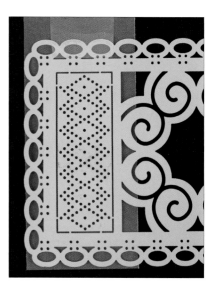

11. Place the embossing folder between the cutting pads and put it in the die-cutting machine. Run the card through the machine and remove it from the embossing folder (see inset).

12. Cut two rectangles of red card 9 x 4cm (3½ x 1½in) and place one on the pricking mat. Secure the template as shown, using low-tack tape.

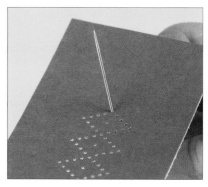

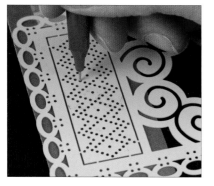

13. Prick the inner diamonds in a row, including the central holes. Do not prick the outer holes.

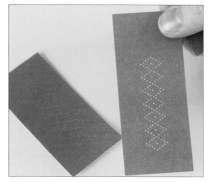

14. Repeat the process on the other piece of red card.

15. Thread a needle with silver thread, secure on the back and bring the needle up through the topmost hole of the row of diamonds.

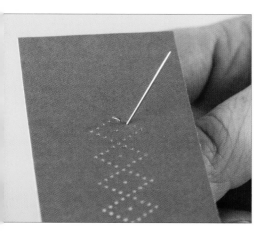

16. Take the needle down through the hole to the right, then up through the next hole.

17. Work down in a zigzag pattern to the bottom point of the row of diamonds.

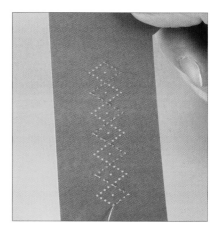

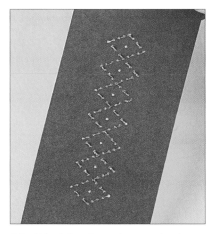

18. Work back to the top in the same way, then secure the thread at the back and cut off the excess.

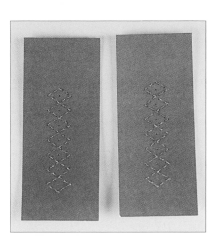

19. Repeat on the other piece of red card.

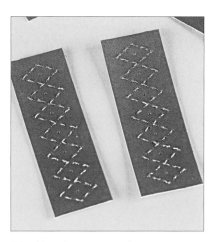

20. Use the paper trimmer to cut both pieces down to 2 x 6cm (¾ x 2¼in) around the embroidery.

21. Cut a 11 x 6.5cm (4¼ x 2½in) piece of gingham card and place 3D foam pads on it as shown.

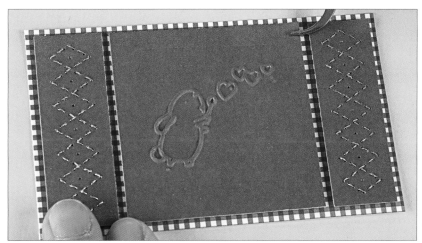

22. Remove the backing from the 3D foam pads and use tweezers to place the embroidered pieces and the embossed piece on to the gingham card.

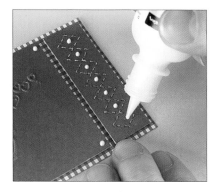

23. Use pearlescent paint to add dots in the middle of the diamonds and in each corner of the embossing. Allow to dry.

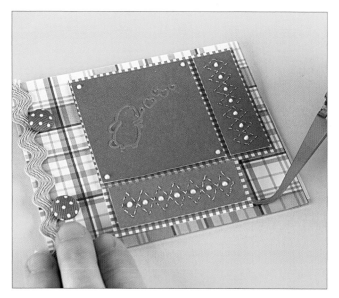

24. Cut off the embroidered piece on the left-hand side (including the gingham it is mounted on), then mount both pieces on the cover using 3D foam pads.

The completed album.

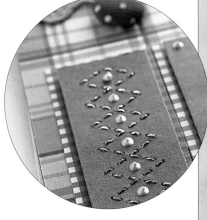

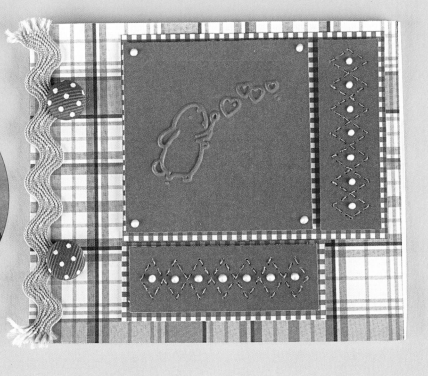

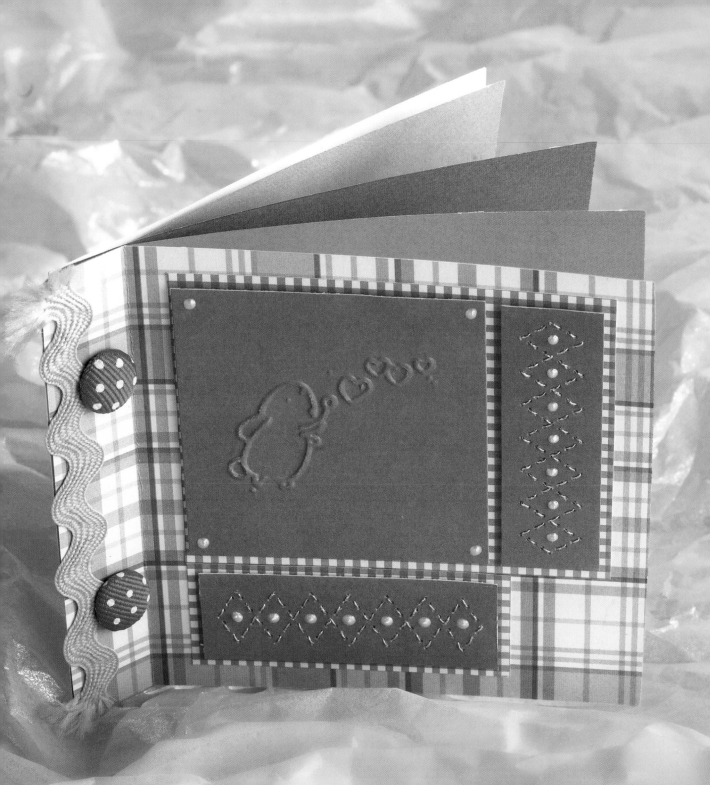

Fill this little album with favourite photos or inspirational quotes and send some cute heart bubbles of love to someone special to show you care.

Embroidery made with this template looks lovely on parchment paper, and also when used to accent shiny metal card.

Adding a few cross stitches will give a little extra interest, and when combined with die-cut shapes the possibilities become almost endless.

Canvas Art

This pretty picture with the delicate embroidery is ideal for home decor and would make a delightful gift for the birth of a baby, or for a christening. The ruffled edges make this piece reminiscent of a quilt block, but it is easier and quicker to make. Combined with pretty embellishments and vintage papers, this is sure to be a favourite project.

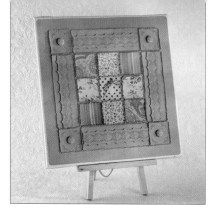

The template (number 500000/5107) used in this project.

You will need

- Blank canvas 30 x 30cm (12 x 12in)
- Blue paper 29 x 29cm (11½ x 11½in)
- Sheets of blue, paisley, striped, pink flower-patterned, small flower-patterned and dotted paper, all 30 x 30cm (12 x 12in)
- Striped ribbon 120cm (48in)
- Cream acrylic paint and brush
- Corner-rounding craft punch
- Light box
- Embossing tool
- Fine-pointed scissors
- Needle and cream thread
- Pencil and ruler
- Pricking tool and mat
- Double-sided tape
- 3D foam pads
- Four blue gingham buttons
- Hat pin embellishment

1. Paint the border of the canvas with cream acrylic paint and allow to dry.

2. Use a corner-rounding punch (see inset) to round each of the corners of the blue paper.

3. Run double-sided tape down the edges of the back of the blue paper, remove the backing and stick the paper on to the canvas.

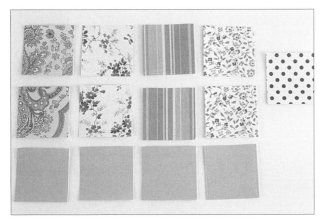

4. Cut 5 x 5cm (2 x 2in) squares: four from plain blue paper, two from paisley paper, two from pink flower-patterned paper, two from striped paper, two from small flower-patterned paper and one from dotted paper.

5. Cut four 15 x 5cm (6 x 2in) rectangles and four 14.5 x 5cm (5¾ x 2in) rectangles from blue paper.

6. Use a ruler and the fine end of the embossing tool to score along the edges of the dotted square, leaving a border of 3mm (⅛in) all round.

7. Using the score lines as a guide, cut the corners off the square with fine-pointed scissors.

8. Cut a frill along the edge of the square from corner to corner, cutting up to the score line each time.

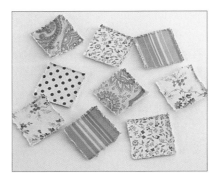

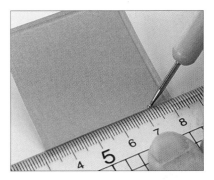

9. Repeat on the other three sides and bend the frills up.

10. Do the same with the other patterned paper squares.

11. Score one of the blue squares using the embossing tool and a ruler.

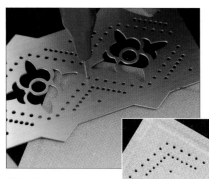
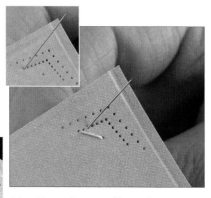
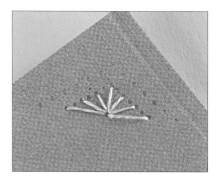

12. Place the template on the blue square so that the edge of the half-diamond is near the scoreline in the corner, then prick both rows of the half-diamond and the central hole (see inset).

13. Thread a needle with cream thread and secure on the back. Bring the needle up through the left corner of the inner half-diamond (see inset), take it down the central hole, then up the third hole of the inner diamond.

14. Work around the inner diamond, taking the thread down the central hole each time. Secure and trim the thread when you finish the motif.

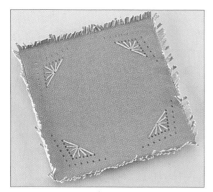

15. Repeat the pricking and embroidery on the other three sides, then trim the corners and frill the edges as before.

16. Do the same with the other three blue squares.

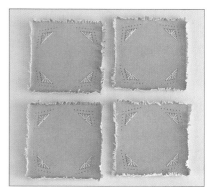

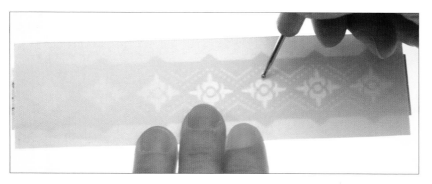

17. Secure the template to one of the smaller blue rectangles with low-tack tape and place it face-down on the light box. Run the embossing tool round the outside of the template and in the central motifs to emboss them.

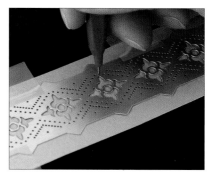

18. Turn the rectangle over and prick all of the holes on the embroidery template.

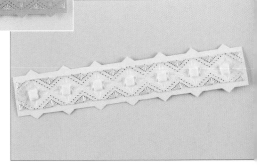

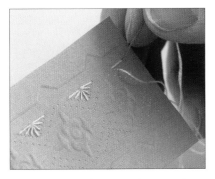

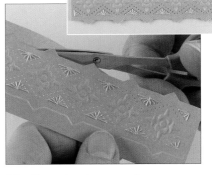

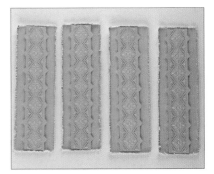

19. Remove the template and stitch the half-diamond motifs in the same way as before.

20. Once both rows of embroidery are worked, cut along the edges, using the embossed border as a guide.

21. Turn the completed piece over and place 3D foam pads on the back.

22. Take one of the larger blue rectangles, score the edges as for the squares, then trim the corners away and frill the edges. Remove the backing from the 3D foam pads on the embroidered piece and place in the centre, then fold the frills up.

23. Use the other rectangles to make three more completed rectangular pieces.

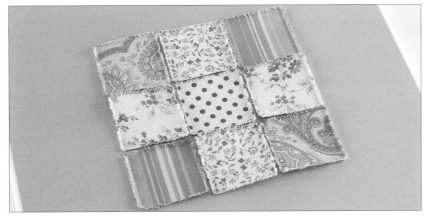

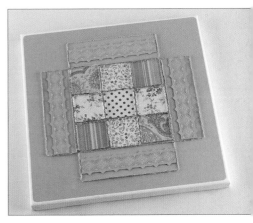

24. Apply double-sided tape to the back of the coloured squares, remove the backing and place them in the centre of the canvas as shown.

25. Attach the rectangular pieces using double-sided tape.

26. Attach the blue squares in each corner using double-sided tape.

27. Use 3D foam pads to attach gingham buttons to the centre of each of the blue squares, and a hat pin embellishment to the centre of the spotted square.

28. Run double-sided tape round the edge of the canvas and run the ribbon over the tape.

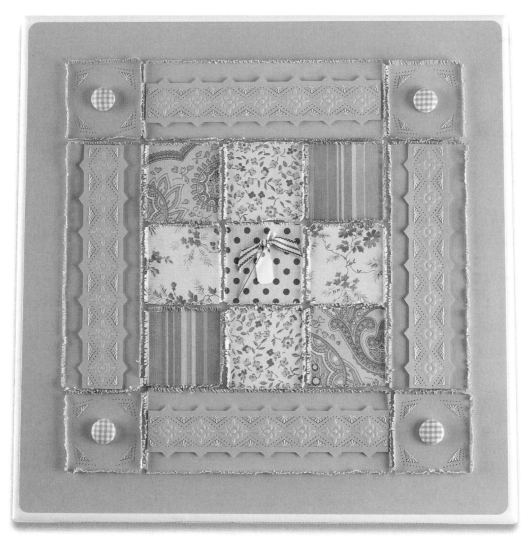

The finished canvas art.

The delicate stitching on beautiful blue paper and the nine patch blocks, all surrounded with a paper ruffle, make this project ideal for home decor.

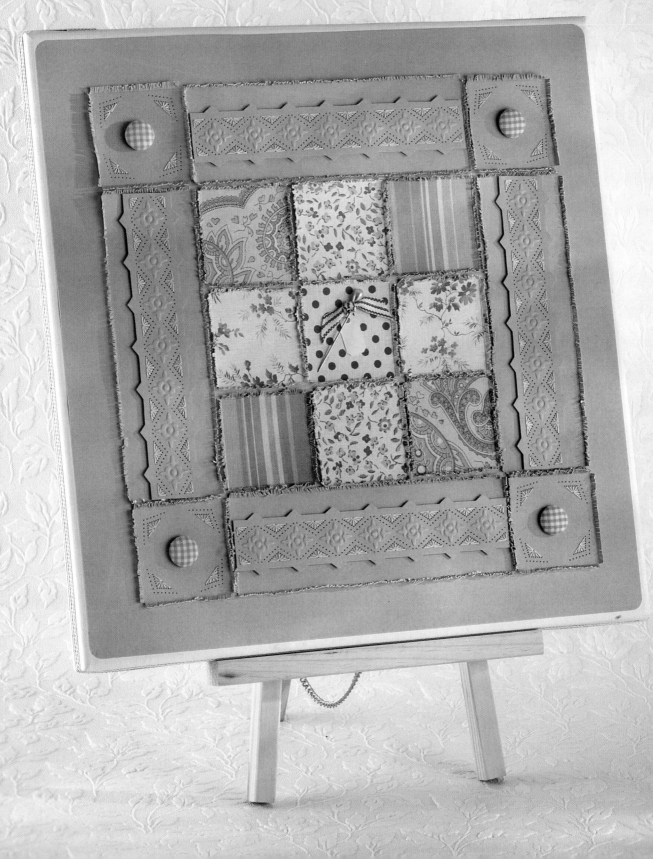

Small canvases are a perfect backdrop for pretty papers with embroidery.

The background colour of these canvases is achieved with two colours of paint and a quick crackle medium.

You can make a card background panel and stitch directly on to it, or you can embroider small pieces of card and then cut out the shape to add depth to the background paper.

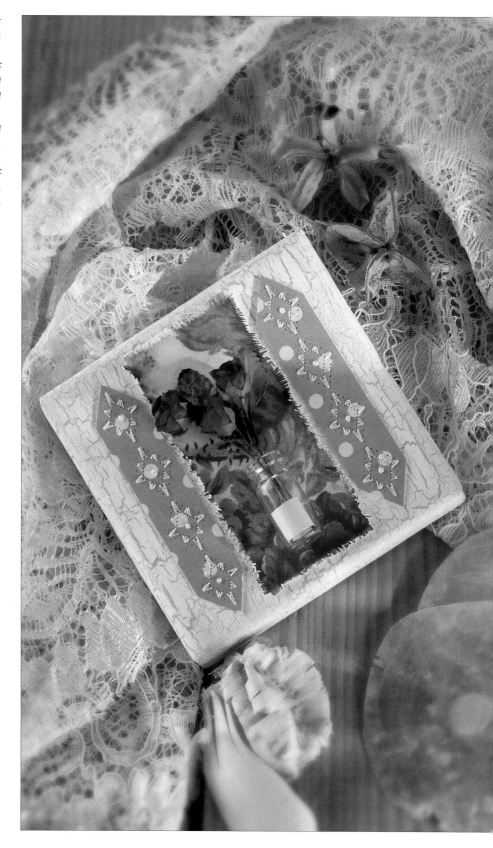

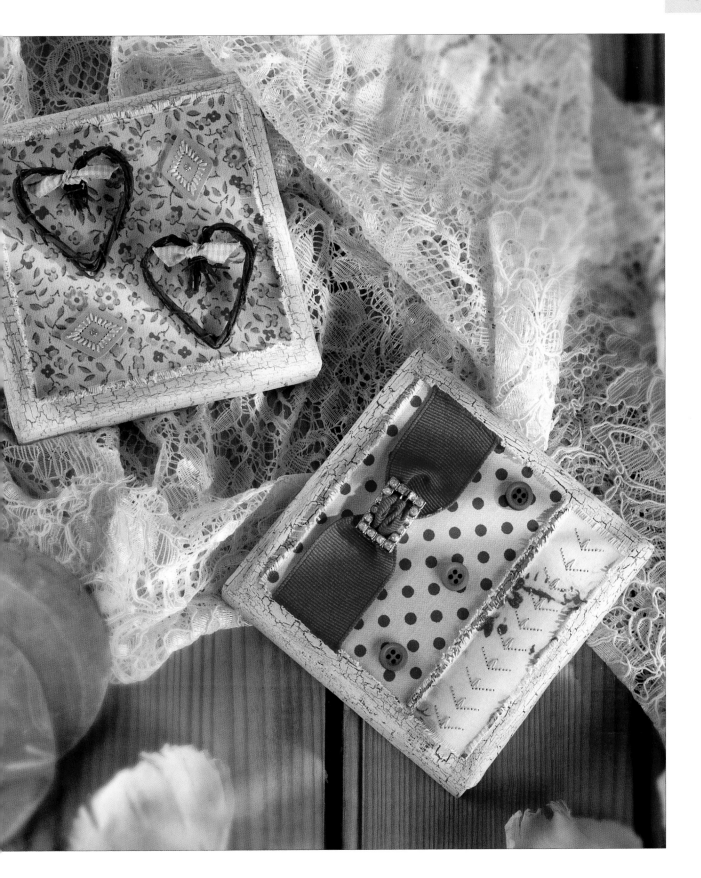

Patterns

The patterns on the following pages are reproduced at three-quarters of the actual size, except where noted. You will need to enlarge these patterns by 133 per cent on a photocopier for the correct size.

——— cut line
– – – fold line

Pattern I for the Spring Bag project on pages 40–47.

Pattern II for the Spring Bag project on pages 40–47.

Pattern III for the Spring Bag project on pages 40–47.

The pattern for the Collage Sweetheart project variation on page 58, reproduced at actual size.

The pattern for the Collage Sweetheart project variation on page 59, reproduced at actual size.

Index

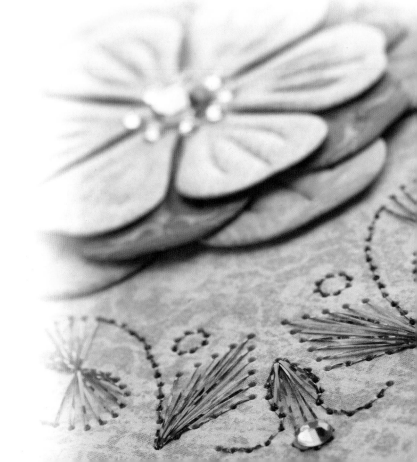